EDGAR DEGAS
in New Orleans

RORY O'NEILL SCHMITT, PhD, &
ROSARY O'NEILL, PhD

THE
History
PRESS

Published by The History Press
Charleston, SC
www.historypress.com

Front cover, top, left to right: *The Cotton Office*, by Edgar Degas, 1873. *Musée des Beaux-Arts, Pau, France*; Photograph of Edgar Degas taken in New Orleans, 1872. The original photograph of the artist has been lost. *Special Collections, Tulane University*; *Madame René De Gas*, by Edgar Degas, 1872–73. *National Gallery of Art, Chester Dale Collection, 1963.10.124*; bottom: *Saint Louis Cathedral in the French Quarter of New Orleans*, 2018. *Photograph by Robert Schaefer Jr.*
Back cover, top: *Portrait of Estelle Musson De Gas*, by Edgar Degas, 1872. *New Orleans Museum of Art*; *bottom*: *Dueling Oaks, New Orleans*, 2022. *Photograph by Rachelle O'Brien*.

First published 2023

Manufactured in the United States

ISBN 9781467153478

Library of Congress Control Number: 2022947161

Notice: The information in this book is true and complete to the best of our knowledge. It is offered without guarantee on the part of the authors or The History Press. The authors and The History Press disclaim all liability in connection with the use of this book.

For Dasan Schmitt, my Love, and Olivia and Rowan Schmitt,
My Dearest Children.

For Bob Harzinski, my Love, and Rachelle, Barret, Rory and Dale,
My Dearest Children.

For our mother city, New Orleans, and for Paris,
who sent us Degas.

CONTENTS

Contents

ACKNOWLEDGEMENTS

G reat faith in Edgar Degas and his New Orleans story fueled us to keep moving forward.

We want to thank our brilliant editor at Arcadia Publishing and The History Press, Joe Gartrell, who encouraged us. We wrote floating on the cloud of hope that you created for us, Joe.

Deepest love goes to our family: husbands Dr. Dasan Schmitt and Bob Harzinski; our actor brother/son, Barret O'Brien; our sisters/daughters, Dr. Dale Ellen O'Neill and Rachelle O'Brien (who contributed magical photographs for this book); and children/grandchildren, Olivia and Rowan.

Our research was enriched by the support of genius curators: Dr. Gail Feigenbaum, Victoria Cooke, Dr. Isolde Pludermacher, Dr. Gloria Groom, Dr. Barbara Bloemink, Dr. Jay Clarke and Tracy Kennan. We are particularly grateful to Gail Feigenbaum, as she was the visionary for the *Degas in New Orleans: A French Impressionist in America* exhibition at the New Orleans Museum of Art. Our deepest gratitude to Isolde Pludermacher, chief curator of Degas' artworks at the D'Orsay Museum and curator of the *Manet/Degas* exhibition.

We'd like to acknowledge additional supporters in Paris: Fanny Matz (documentary studies officer, Musée d'Orsay et Musée de L'Orangerie), Dr. Caroline Corbeau-Parsons (curator of drawings/conservatrice des arts graphiques, Musée D'Orsay), Isabelle Gaetan (chargée d'etudes documentairs, Musée D'Orsay) and Paul Perrin (conservateur peinture/

curator of paintings, Musée D'Orsay). Special thanks to the Irish Cultural Center for hosting our residency in Paris: the ambassador of Ireland to France, Niall Burgess; Irish Cultural Center's director, Nora Hickey M'Sichili; and the center's staff, Yann Le Cadre.

Thank you to brilliant New Orleans history scholars at Loyola University, New Orleans: Dr. Barbara Ewell, Dr. C.W. Cannon and Dr. Justin Nystrom. Our appreciation to additional scholar Dr. Tara Dudley (University of Texas at Austin), historian Jean Jacques Patard (Canada) and conservator Kate Smith (Painting Lab at the Harvard Art Museums). We'd also like to thank Edgar Degas' great-great-grandniece in America, Terry Martin-Maloney, and Norbert Soulié, a descendant in France of a Degas New Orleanian relative, for their commitment to preserving family histories.

Cheers to the dreamers who dreamed with us: the photographers, like Cheryl Gerber and Robert Schaefer Jr., who created the vision; and the archivists who discovered lost clues, Jessica Dorman and Jennifer Navarre from the Historic New Orleans Collection, Leon Miller (curator, Louisiana Research Collection at the Tulane University Special Collections) and David Becnel.

Our gratitude to the French Consulate and to Jacques Baran (cultural attaché of France to New Orleans). We also thank Michèle Puyserver (the Board of France–Louisiane), as well as Pauline Lemasson (development chairperson, Association of American Women in Europe), who invited us to present our research. Thank you also to the Fulbright Commission, which hosted Rosary's five Fulbrights to Paris to study Degas.

Kudos go to our literary agent, Linda Langdon, and theater agent, Tonda Marton, and her colleague in Paris, Dominique Christophe. Warm appreciation to our film producer at MediaFusion, Carole Bidault de L'Isle, who is actively supporting our screenplay, *Degas: The Impressionable Years.*

Thank you to our friends in film: Mark Duplass, Bobby Morenos, Neil McEwan, Loren Paul Caplin, Oley Sassone, Gary Lundgren, Todd Wilson, Alayha McNamara, Laura Singleterry, Molly Ann Jacobs, Dónal O'Neill, Carl Tooney and Jennifer Romine. Our gratitude to fantastic writers Carole diTosti and Meagan Meehan. We value your friendship.

We adore and thank our inspiring friends and colleagues in France: Jeanne Fayard, Genevieve Acker, Sylvie and Christian Raby, Annick Foucrier, Alice Diaz Chauvigné, Christel Coulon and Florie DuFour.

We deeply admire and appreciate our family and friends in the Crescent City: Richard O'Neill ("Papa O"), Nell Nolan, Anne Pincus, Cybèle Gontar (Degas Gallery owner/director in New Orleans), Ann Jarrell, Georgie

Simon, Rexanne Becnel, Anne Burr, Laurie Sapakoff and Evan Cohen, Dr. Katie Keresit, priestess Sally Ann Glassman, Mary Anderson, Stephen and Pat Hartel and Joe and Jean Hartel.

We adore additional family in Arizona: Brett, Vicki, Jasmine and Maya Schmitt. And special big hugs to cousin Jay Nix and his Parkway Bakery, who believes in and champions all good creative things New Orleans.

Friends, we salute you: Bill Goodman, Rachel Friend, Susan Izatt, George Trahanis, Jim Bosjolie, Jennifer Weidinger, Meghann Powers, Lauryn Bymers, Dawn Henry, Laura Conner, Joy Williams, Melinda Thomas, Monica Keyes, Ben Golpa and Jenny Bagert.

And of course, thank you to Insiah Zaidi, who believed in this project and supplied immediate and invaluable assistance from Germany at the University of Bonn.

Special thanks to museums for their support of this research: Harvard University Art Museums, Dumbarton Oaks Research Library and Collections, New Orleans Museum of Art, Minneapolis Institute of Arts, the Detroit Institute of Art, the Art Institute of Chicago, Harvard Art Museum and the D'Orsay Museum.

Thank you to the Motherland, New Orleans.

We salute you, Edgar Degas, and your mother, Célestine Musson De Gas, and her mother, Marie Rillieux Musson, and her family who have resided in New Orleans for generations.

And the most glorious, thanks to God and His angels of mercy, who keep us artists inspired.

Blessings from Royal Street, in New Orleans, and from Scottsdale, Arizona, and Paris, France.

—Rory O'Neill Schmitt, PhD, and Rosary O'Neill, PhD

PREFACE

I n this book, we will rip off the veil and show you Edgar's life in New Orleans. Edgar, that dreamer, that poet, that disciplined maniac who wouldn't stop painting and perfecting his art. And the journey into New Orleans was a journey into adversity and death.

WHO

We are cradle New Orleanians and artists. Growing up, we had no idea that Edgar Degas' mother was also from New Orleans and that he'd come here to save her destitute family and to find some path for his "lost" soul. We'll get to why he was lost later. But the sea beckoned, her billowing giant sailboats luring him to brave days onboard and to make it to New Orleans. He was sailing to the mythic land of his Creole mother, the land of bayous and wide-limbed oak trees, that she had perhaps described to him before her untimely death when he was thirteen.

So, dear reader, we, mother-and-daughter team from New Orleans, are going to spin back in time with you and follow Edgar on his journey.

There is something wonderful about writing as mother-daughter, fourth and fifth generation in the city where our ancestors are buried. When we describe the houses in the Crescent City, we've lived inside them. When we discuss the churches, we've prayed there. When we talk about Carnival season, we've celebrated it. We've walked the streets Edgar walked, from

Above: *Oak in the Bayou*, New Orleans, 2022. *Photograph by Rachelle O'Brien*.

Left: *St. Louis Cemetery Sign*, New Orleans, 2022. *Photograph by Rachelle O'Brien*.

Lower Garden District (bench), 2022. *Photograph by Cheryl Gerber.*

Saint Louis Cemetery #1, New Orleans, 2016. *Photograph by Robert Schaefer Jr.*

Esplanade to Carondelet, stepped through the windowed galleries and front parlors, gazed up at the twenty-foot-high chandeliered ceilings, attended christenings and weddings and followed funeral processions to aboveground tombs at the St. Louis Cemetery, where Edgar's family mourned. We've danced in funeral marches or chased after Mardi Gras parades, cried on

benches next to the Mississippi River and in Audubon Park. New Orleans is a land of extreme mourning and wild, over-the-top celebration. More than anything, even in times of woe, it is the town of distraction.

After all, isn't Mardi Gras what New Orleans is famous for? Carnival, that period of processions, music, dancing and the use of masquerade. Don't we all need a little New Orleans magic sometimes?

What

Edgar came here to be reborn. His mother, an amateur opera singer, had been the charmed presence of his boyhood. Maybe in her city, he could see inside the souls of the people he painted in a new way.

He hoped to free or release something in himself; he may not have known what. Few of us know what propels us to take these dangerous voyages to unknown places. But he knew time was running out. He was thirty-eight (old for a painter), with moderate success in his pocket. Average life expectancy for men was forty-two. Maybe he dreamed of New Orleans, this mythic land

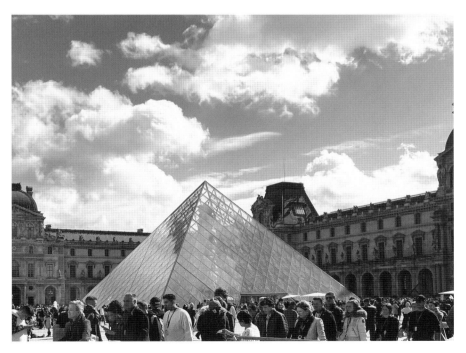

The Louvre Museum, 2022. Photograph by Rory O'Neill Schmitt.

Above, left: *Greek and Roman Sculpture Garden*, the Louvre Museum, 2022. *Photograph by Rory O'Neill Schmitt.*

Above, right: *Winged Victory*, the Louvre Museum, 2022. *Photograph by Rory O'Neill Schmitt.*

Opposite: Religious art, the Louvre Museum, 2022. *Photograph by Rory O'Neill Schmitt.*

for tourists, this place famous for honeymoons, starlight cruises, toe-tapping music and dancing under the stars.

Parisians had an idealized view of what La Nouvelle Orléans was, and Edgar was no doubt shocked by what he found. Could he paint what he saw and felt, really? Could he care for or would he condemn the people he loved, the family that had retreated to Paris for his protection during the American Civil War? Could he paint them and superimpose a patina of beauty amid their crumbling worlds? Could he paint past the pain and capture his family in New Orleans?

An enormously disciplined artist, Edgar had studied with the best painters at the best schools in Paris, the mecca of art. He'd spent twelve to eighteen hours per day copying masterpieces at the Louvre, the greatest museum in Paris. He was restless to find a unique path, to make a mark, to be a star. In Paris, being a painter was considered the next step to being a god, but in New Orleans, Edgar found that being a painter was deemed by many a businessman, the next step to being a fool.

The work of an artist is founded in obstinance and denial, painters getting up at the crack of dawn, writers reworking a sentence twenty times only to cut it. Though many in New Orleans didn't quite understand Edgar's drive, this didn't force him to fall into indolence, lethargy or despair. He kept his discipline and his commitment to paint. He studied, drew and redrew the troubled family greeting him in 1872.

WHERE

New Orleans, once the capital of Louisiana, is the farthest city south you can go and not drop off into the ocean. When Degas' mother, Célestine Musson, lived here, it was a bustling port city with riverboats as the capital city of Louisiana. The world-class city had attracted French painters and world-renowned singers and actors. Jean-Jacques Audubon, a French Naturalist painter, had inspired Edgar to want to do his signature work in Louisiana. But in Reconstruction Louisiana, Edgar would find the city was no longer a cultural mecca.

WHEN

It was 1872, and operas and theaters had closed. Disease prevailed. Death was in charge.

Edgar's two brothers, Achille and René, were already in New Orleans seeking their fortunes. But he soon discovered they were floundering.

Edgar loved our city and missed his departing train several times. But successive shocks he experienced in New Orleans led him to leave in 1873, never return and start a new kind of art, called Impressionism.

WHY

Edgar's New Orleans story is shadowed in blame, a shame so profound his descendants reverted their name to their mother's maternal name, Musson. Some say that a redo of a cemetery and the discovery of a tomb of an infant De Gas led to the unmasking of more of the story a few decades ago.

Our goal is for readers to see, hear, sense and feel what it was like for Edgar Degas in New Orleans, to understand an experience that could have launched his career. It's our dream for you, our readers, to walk a day in the life of Edgar Degas on arriving and then on leaving the Crescent City. Like Edgar Degas, we carry that old French city, with its lush foliage and mama oak trees, in our hearts.

We have lived as insiders and outsiders (New York/California/Arizona) with our southern accents, and we understand how fascinating New Orleans can feel, and indeed is. Our books on New Orleans (*New Orleans Voodoo: A Cultural History* and *New Orleans Carnival Krewes: The History, Spirit and Secrets of Mardi Gras*) examine mysterious practices rooted in history, culture and art.

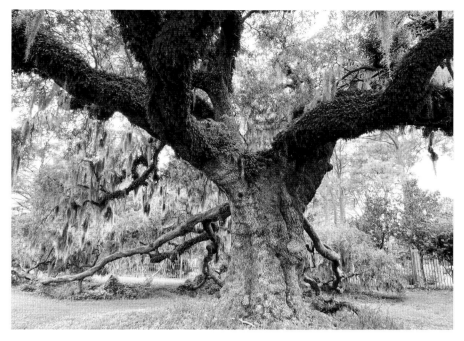

Mama Oak Tree, New Orleans, 2022. *Photograph by Rachelle O'Brien.*

Together, we'll discover the events that wrenched Degas' heart and sent him to the shattered sickrooms and parlors of New Orleans. Edgar landed here with a passionate curiosity for all he could see and feel. He had money in his pockets and love in his heart—love for his cousins (especially Estelle, whom he discovered was going blind), love for his uncle (who was going bankrupt), love for the cotton business (which was closing), love for plein air landscapes (which were unpaintable because of the brutal sun and his failing eyes).

Degas left quickly and never came back. What happened? What were the secrets that blew open like hand grenades?

You'll be as shocked as we were when you find out.

—Rory O'Neill Schmitt, PhD, and Rosary O'Neill, PhD
New Orleans, Louisiana; Scottsdale, Arizona; and Paris, France, 2023

Chapter 1

THE BACKSTORY ON RUPTURED LOVE

Before Edgar stepped foot on Louisiana soil, his maternal ancestors had walked here for generations. The day came when his beautiful, fantastical mother, Célestine Musson,[1] would be born. But only four years later, Louisiana's angels whispered her mother's name, Marie Céleste,[2] through the rainy, sweet streets of the Garden District and ripped her soul from the earth.

And so, Edgar's connection to New Orleans is rooted in love and rupture.

Let's briefly glimpse his Louisiana ancestors, who delivered the painter who was to become known as French, many forgetting his mother was indeed American.

MOTHER NEW ORLEANS

When Célestine's mother died, her bold, grieving father, Germain Musson, wondered how could he, a widower, face everyday life in New Orleans? The prying, supposedly compassionate questions, the carapace of funeral attire, the bleak faces of his five young children, whom he was now raising alone.

How did he soothe his four-year-old daughter, confused and missing her mother? Germain was determined to control what would happen next for his children, especially his youngest daughter, Célestine (whose name meant "heaven"), as well as for his son Michel,[3] who would become Edgar's famous uncle in the cotton office.

Above: *Cathedral*, 2016. *Rosary O'Neill.*

Opposite, top: *The Pantheon, Paris*, 2022. *Photograph by Rory O'Neill Schmitt.*

Opposite, bottom: *Tuileries Gardens and Fountain, Paris*, 2022. *Photograph by Rory O'Neill Schmitt.*

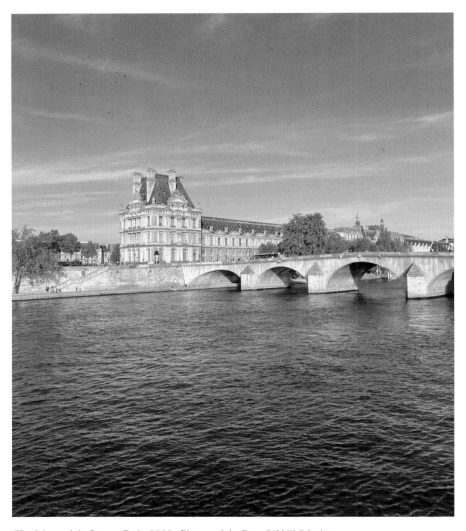

The Seine and the Louvre, Paris, 2022. *Photograph by Rory O'Neill Schmitt.*

Germain whisked his children over the ocean to Paris. After all, he[4] was a traveler, a French Huguenot, daredevil, man of genius and action. He had found wealth in Mexican silver mines, cotton and sugarcane ventures.[5] Only twenty-two when he immigrated to New Orleans from Haiti, now at thirty-two, he set off again. And this time, he brought his progeny: Michel,[6] Ann Eugenie,[7] Célestine,[8] Louis Eugene[9] and Henry Germain.[10] He could control things that weren't heart-related or subject to disease or death.

Left: *Statue at the Luxembourg Gardens, Paris, 2022. Photograph by Rory O'Neill Schmitt.*

Below: *Luxembourg Gardens, Paris, 2022. Photograph by Rory O'Neill Schmitt.*

Boats on the Seine, Paris, 2022. *Photograph by Rory O'Neill Schmitt.*

Germain believed Paris would heal them as a family: great parks, like Luxembourg; great fountains, like the Tuileries; great monuments, like the Panthéon; great castles, like Versailles; great churches, like Chartres; great rivers, like the Seine. Germain aimed to fill the hole of their mother's death by lavishing his children with an opulent lifestyle. Paris was where Germain, too, could forget.

Paris, the City of Love

Célestine blossomed into a breathtaking young woman. In 1832, a love affair sizzled in the courtyard between her house and the neighbor's. She was seventeen, a stunning opera singer. A virile twenty-five, Auguste De Gas[11] was polished, well-read and discriminatingly refined in Italian and French. Perhaps he heard her singing in their shared courtyard. Maybe he watched her strolling, corseted, bonneted, petticoated in rich pastel silks, an abundance of bows and ribbons, a voluminous skirt.

Their connection was electric. Auguste and Célestine both had been reared by doting, daring, entrepreneur fathers[12] and schooled to appreciate fine art and beauty. Soon, Auguste would be inheriting his father's two banks in Paris and Naples.

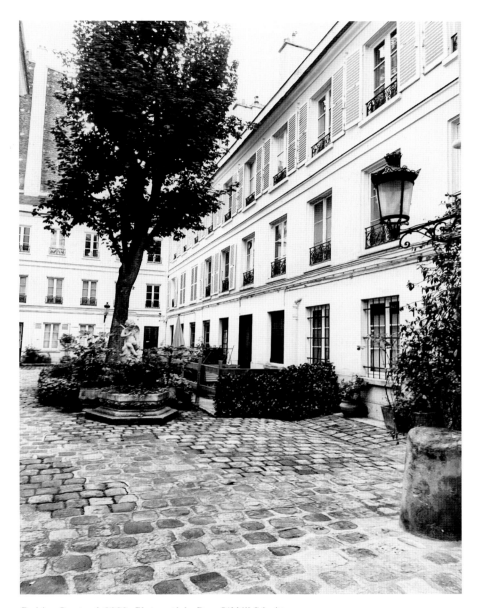

Parisian Courtyard, 2022. Photograph by Rory O'Neill Schmitt.

Left: *Hilaire De Gas*, detail, by Edgar Degas, Musée D'Orsay, 2022. *Photograph by Rory O'Neill Schmitt.*

Right: *Germain Musson or Rene-Hilaire De Gas*, by Edgar Degas, 1853–55. A 1998 exhibition at the Regional Archeological Museum in Aosta, Italy, identified this painting as one of the artist's grandfathers. *D'Orsay Museum Library.*

Auguste married Célestine as soon as he could in 1832.[13] It seemed as if the angels of Paris were giggling and whispering at the marriage. Delight fueled delight as the couple's progeny began early, starting with the triumphant birth of a son, Hilaire Germain Edgar De Gas,[14] on July 19, 1834. Both grandfathers, the namesakes, Germain Musson and Hilaire De Gas, were overcome with glee.

To rejoice, Auguste bought a Creole cottage on North Rampart Street in New Orleans for his newborn son. By purchasing New Orleans property, Auguste connected Edgar to his mother, her people, her home. It was his piece of New Orleans.

To celebrate Edgar's baptism, Grandfather Germain, who had moved back to New Orleans, traveled to Paris. He commissioned a pastel portrait of his daughters Célestine and Eugenie and took it back with him, not knowing it would become a memorial portrait of Célestine.[15] Again, no one foresaw her death knell.

In eleven years, Célestine birthed[16] five children who survived: Edgar, Achille,[17] Thérèse,[18] Marguerite[19] and René.[20] With her family, Célestine shared her longing to return to New Orleans. But the land of her childhood

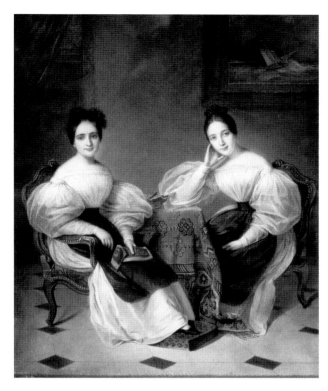

Mme. Auguste De Gas, née Musson (mother of Edgar Degas), and her sister, Duchesse de Rochefort, by Catherine Guy Longchamps, 1835. *The Historic New Orleans Collection.*

seemed impossibly remote, despite a reminder visit from her glamorous father, Germain, and her industrious brother Michel.

But the angels of death were calling her name through the boulevards and cobblestoned streets of Paris. She survived childbirth only to die tragically two years later, in Paris, at the age of thirty-two.

When she died, Edgar was on the cusp of manhood at age thirteen. Already he'd found his love of drawing while at boarding school. He never really got to tell his mom goodbye. She was fine and then, suddenly, she was gone. Permanently. His mother's sudden death likely tortured him long after the casket lid was shut.

Do boys ever forget their mothers, especially ones who die young, their faces indelibly frozen in memory? It's hard to conceive, but Edgar lived in a time of broken hearts, when so many mothers died in childbirth and so many sons buried their siblings, as indeed Edgar had the brother[21] who came right after him.

In seeing the genius of Edgar's later artwork, we must ask ourselves: Is great talent indeed birthed through suffering? Is the cycle of love and loss something that plagued Edgar since his youth?

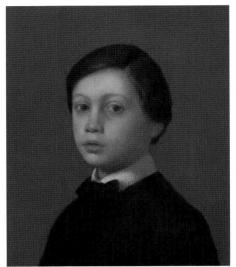 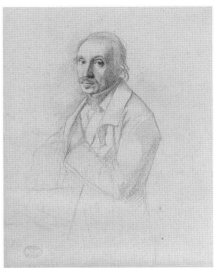

Left: *René De Gas*, by Edgar Degas, 1855. *National Gallery of Art, Collection of Mr. and Mrs. Paul Mellon, 1995.47.8.*

Right: *Auguste Degas*, by Edgar Degas, 1854–64. *Art Institute of Chicago, Gift of Dorothy Braude Edinburg to the Harry B. and Bessie K. Braude Memorial Collection, 2013.920.*

As the eldest, Edgar likely consoled his siblings: eleven-year-old Achille, seven-year-old Thérèse, five-year-old Marguerite and two-year-old René. He was pushed to become a caring guardian and fierce protector, especially of René, who was just a toddler.

His father never remarried, so theirs became a motherless house. Gone were his mother's stories of New Orleans, her sometimes speaking English, her joy. Edgar had not yet gotten to know New Orleans, and he likely grieved because he hadn't learned enough. His New Orleans relatives dwelled five thousand miles away.

Death of a mother clutched him like a permanent claw, with its horror reverberating through his bones. In the days, weeks and months that followed, Edgar likely experienced the pangs of a deep heartbreak like he couldn't have imagined. How could Edgar quell his pain? Could he encapsulate himself in another world of his imagination? Perhaps art would become the healing elixir.

As birth can kill, art can save. Edgar's father was a connoisseur of early Italian art, and he took the time to show artwork to Edgar. Auguste was forty, Edgar thirteen. In a time when most men were growing their businesses,

Auguste De Gas was growing his son. We imagine Edgar and Auguste explored art collections, quenching sorrow in the deep emotional expressiveness in the beauty of Botticelli. Auguste appreciated his son's obsession with painting, a rare thing when we recall Auguste was a banker.

Edgar began to draw more and more, replacing feelings of loss with a passion for art. He was likely soothed by the notion that portraits immortalize the faces of those you love.[22] One wonders if he yearned to see the sole portrait of his mother that his grandfather took with him back to New Orleans.

The more Edgar studied art, the more he realized he had to practice and study with the best. His painting idol, Jean-Auguste-Dominique Ingres,[23] told him, "Draw lines, lots of lines, either from memory or from nature."[24] Edgar carried a notebook everywhere. He even arrived clasping one in New Orleans.

Edgar painted while attending Louis-le-Grand school, while completing an apprenticeship at the Louvre, while his cousin Désirée "Didi" Musson visited France, while studying art in Italy and spending time with his Italian relatives. Even when his aunt Laure was pregnant and mourning his grandfather Hilaire, Edgar was painting her.[25]

Eventually, Auguste began to worry about his son's career. He wrote to his brother-in-law Michel in New Orleans: "Our Raphael is always working, but hasn't yet produced anything accomplished, meanwhile, the years go by."[26]

Self-Portrait, by Edgar Degas, 1857. *Metropolitan Museum of Art. Bequest of Walter C. Baker, 1971.*

Désirée Musson drawing by Edgar Degas. *Musée D'Orsay library. Photograph by Rory O'Neill Schmitt, 2022.*

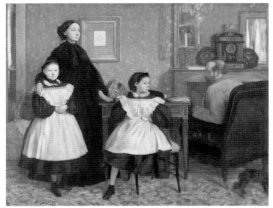 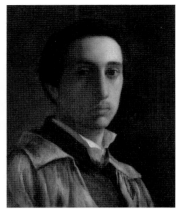

Above, left: Portrait of the Family (The Bellelli Family), by Edgar Degas, 1858–67. *Musée D'Orsay, acquired by the Musée du Luxembourg at the sale of the Degas studio, 1981. ©RMN-Grand Palais (Musée d'Orsay)/Hervé Lewandowski.*

Above, right: Self-Portrait, by Edgar Degas, 1855–56. *The Metropolitan Museum of Art, bequest of Stephen C. Clark, 1960, 61.101.6.*

Opposite: Edgar Degas' family tree in America. *Created by Insiah Zaidi, University of Bonn, Germany, and the Arcadia Publishing design team.*

Could Edgar put on a pressed suit, keep regular hours and be content inside an office? Auguste's other sons didn't have the ambition or industry to run anything, much less a bank. Edgar probably felt a little guilty knowing he would never take over the family business. As a concession, he briefly attended law school but dropped out.

The drive to create compelled Edgar, as did seeing his New Orleans family. Traumatized from the Civil War, the Mussons arrived in France in 1863. What was it about his family and their grief-stricken appearance that so riveted Edgar's eyes and shook his soul?

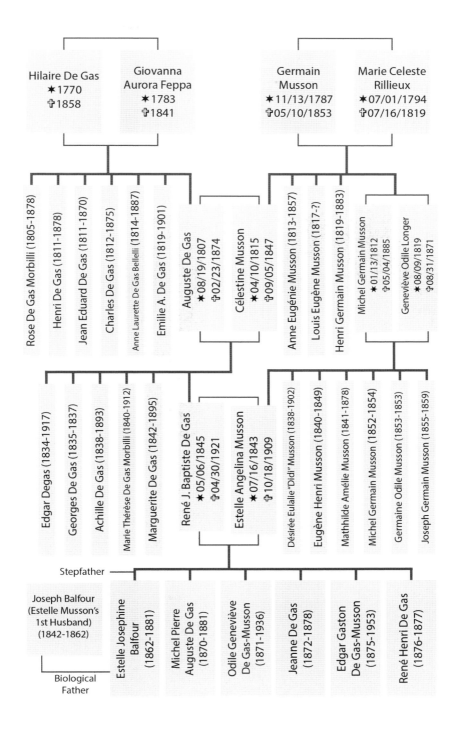

Hilaire De Gas
✴1770
✟1858

Giovanna
Aurora Feppa
✴1783
✟1841

Germain
Musson
✴11/13/1787
✟05/10/1853

Marie Celeste
Rillieux
✴07/01/1794
✟07/16/1819

Rose De Gas Morbilli (1805-1878)

Henri De Gas (1811-1878)

Jean Eduard De Gas (1811-1870)

Charles De Gas (1812-1875)

Anne Laurette De Gas Bellelli (1814-1887)

Emilie A. De Gas (1819-1901)

Auguste De Gas
✴08/19/1807
✟02/23/1874

Célestine Musson
✴04/10/1815
✟09/05/1847

Anne Eugénie Musson (1813-1857)

Louis Eugène Musson (1817-?)

Henri Germain Musson (1819-1883)

Michel Germain Musson
✴01/13/1812
✟05/04/1885

Geneviève Odile Longer
✴08/09/1819
✟08/31/1871

Edgar Degas (1834-1917)

Georges De Gas (1835-1837)

Achille De Gas (1838-1893)

Marie Thérèse De Gas Morbilli (1840-1912)

Marguerite De Gas (1842-1895)

René J. Baptiste De Gas
✴05/06/1845
✟04/30/1921

Estelle Angelina Musson
✴07/16/1843
✟10/18/1909

Désirée Eulalie "Didi" Musson (1838-1902)

Eugène Henri Musson (1840-1849)

Mathhilde Amélie Musson (1841-1878)

Michel Germain Musson (1852-1854)

Germaine Odile Musson (1853-1853)

Joseph Germain Musson (1855-1859)

Stepfather

Joseph Balfour
(Estelle Musson's
1st Husband)
(1842-1862)

Estelle Josephine
Balfour
(1862-1881)

Michel Pierre
Auguste De Gas
(1870-1881)

Odile Geneviève
De Gas-Musson
(1871-1936)

Jeanne De Gas
(1872-1878)

Edgar Gaston
De Gas-Musson
(1875-1953)

René Henri De Gas
(1876-1877)

Biological
Father

Chapter 2

NEW ORLEANS GIRLS GO TO FRANCE

The brutality of war loomed before Edgar in the faces of his terrified relatives when they landed in Paris in the heat of summer. One was a nineteen-year-old widow carrying an infant; another was helping along her failing mother. They were four females fleeing a world where men were dying young in the bloodiest war in American history. Women nervous, sweaty in the heat, exhausted from travel on a sailing ship over a perilous ocean. Women holding back tears with their sleeves, their fists, their gritted teeth.

New Orleans had an unexpected death herself. Immediately, this city, the largest and richest one in the South, had been the first to fall in the Civil War.

The Crescent City was simmering with tension from the occupation of Union soldiers. Violence was erupting in the streets. As conditions worsened, Edgar's uncle Michel shipped his wife, two unmarried daughters and infant granddaughter to France to save them. He kept his daughter Mathilde home because she was expecting a baby, an infant whom she would soon bury.[27]

Unmentionable fears hovered in New Orleans: Would this illness bloom into death? Would that soldier disappear? Would that baby stop breathing? No one knew when Aunt Odile, cousins Estelle and Désirée[28] and baby Jo would return to Louisiana—and who would be alive when they did. Theirs was a flight into the unknown.

Edgar was prepared to grit back any anxiety, to remain as hopeful as possible. He sensitively shared news with his uncle and wrote, "I am sending you my love as your nephew and even a little as your son."[29]

Death had assaulted Edgar early on, had stolen someone whom as a child he loved more than life, someone he never thought he could do without. Edgar knew how to use compassion to minimize death's bite. He wrote to Uncle Michel:

> *My dear uncle, your family arrived here last Thursday, 18th of June and is now completely ours. Things couldn't be better, or simpler. Accept all my warm regards. Your photograph is definitely you, although it conveys less of the air of humor of which René has frequently spoken, an air which I can scarcely find* [in the photograph]. *Our Aunt Odile is walking very well, and I admit that, judging from the portrait we have of her, I expected her to be less spry. Didi is really her first mate....Please give our warm regards to the pleasant and pretty Mathilde.*

Part of Edgar's training as an artist required him to observe details, to identify emotions expressed through the effects of light and shadow. He probably knew when his family was too weary or terrified to talk, but that beauty could calm the broken heart. The vital, full, joyous splendor of France contrasted with the violence and desolation of war-torn America. Edgar couldn't stop the battering of war deaths, but he could show relatives the French countryside with its haystacks, blue skies, charming medieval villages with fairy-tale castles, lush green vineyards and fragrant lavender fields.

Perhaps his aunt, only forty-five but in fragile health with a failing leg and crippled hand, could find relief in Bourg-en-Bresse, a colorful resort town in the Alps. Here, locals strolled by the water, took picnics and visited the nuns' apothecary. In the fifteenth-century Gothic cathedral, Catholics prayed to the town's patron saint, the Black Madonna.

And then there was Estelle, whose name meant "star." She was his mother's lookalike, the cousin Edgar was most drawn to, people said.

Having studied the ravages of war in paintings at the Louvre, Edgar couldn't help but cringe at Estelle's blighted face. Estelle, just nineteen, nervously clutching her eight-month-old, was already a Civil War widow. She had cried so much that her eyes were almost bulging out of their sockets.

A year before, Estelle had married a dashing soldier, Captain Joseph Balfour, the nephew of Confederate president Jefferson Davis. She barely had time to adjust to her husband being in the war when a letter[30] came saying he was dead. He was only twenty, and it was the second day of the Battle of Corinth, Mississippi. In shock, she probably broke down,

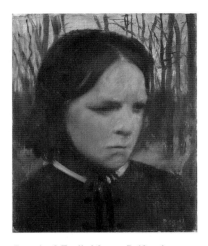

Portrait of Estelle Musson Balfour, by Edgar Degas, 1863–65. *The Walters Art Museum, 37.179.*

cried convulsively and wailed into the night, bringing on the early birth of their daughter, Josephine.

Edgar connected with her trauma. "As for Estelle," he said, "poor little woman, it's hard to look at her without thinking that her head has hovered before the eyes of a dying man." In 1865, Edgar dove into her grief by painting her, ghostlike and surrounded by barren trees in his *Portrait of Estelle Musson Balfour*. He portrayed her downcast eyes as sunken holes, foreshadowing her eventual blindness.

Edgar's own eyes would later become damaged as a soldier. Loss of vision was perhaps an invisible cord of connection between them. Late in life, he, too, would go completely blind. For a painter, that was the fear he dared not speak.

As time passed in Bourg-en-Bresse, the Musson women probably felt increasingly isolated. They needed reassurance and comfort. Edgar and his siblings no doubt tried to help, but information on Louisiana was sparse and hard to come by in the Parisian newspapers, the major source of knowledge.

Edgar may have sat with them as they opened the paper, bracing themselves at the turn of a page to take in the somber war news: reports of major battles, like the Battle of Chickamauga (September 19–20, 1863) and Battle of Cold Harbor (May 31–June 12, 1864). So many unidentified soldiers, so many missing, so many captured, so many deathly sick. In a few years, 620,000 men would die—1 in 5 in America, the greatest percentage of whom was Southern.[31] It took courage to keep reading the newspapers, opening the mail to the almost too-bad-to-be-believed news.

Edgar may have harnessed the Musson women's despair in his last history painting. At the same time they were visiting, from 1863 to 1865, Edgar painted *Scene of War in the Middle Ages*,[32] and some said Edgar was depicting atrocities against women in the American South.[33] Does the central archer have a gentle face like Estelle's? We know he made a preparatory drawing of the archer as a woman and later added a hood. Was Edgar transforming his tragic cousin Estelle, holding a piercing bow, now the victor, no longer the victim?[34]

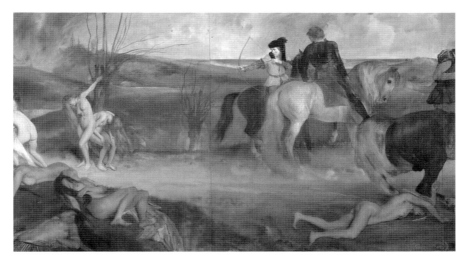

Scene of War in the Middle Ages, by Edgar Degas. *Musée D'Orsay, RF 2208.*

News from back home progressively worsened. To lighten the mood, Edgar distracted the Musson women with a holiday visit. Edgar's sister Marguerite wrote, "Edgar left from here yesterday to go spend the new year holidays with them, and he is so gay that he will amuse and entertain them a bit. He took with him a lot of pencils and paper to draw Didi's hands in all due form, because it is rare to find so pretty a model."

The French-Louisiana family celebrated New Year's (both in 1864 and 1865) probably with the Réveillon ("Awakening"), a late-night feast of traditional dishes like pancakes, foie gras and caviar. They may have toasted champagne and cheered, "Bonne Année!" even though they didn't know if the year to come would be good at all.

Edgar arrived "loaded with packages up to his neck." Cousin Didi wrote, "I was…very surprised on returning to our house to find Master Edgar busily emptying a little trunk full of gifts, toys, candy, marrons glacées."[35]

Indeed, he lifted their spirits. In France, the anxious New Orleans women enjoyed little delicacies, breathed in the mountain air and felt genuine support.

But not for long. By Christmas 1864, it was clear that the Confederacy had lost the war. Trade started to reopen,[36] and cotton was coming through New Orleans. Uncle Michel had invested heavily in the Confederate cause, a financially foolish thing to do, and the war was a financial disaster for him and for his brother-in-law, Auguste.[37] Naively, Uncle Michel thought he could easily rebuild his fortune.

René De Gas, the Artist's Brother, by Edgar Degas, 1861–62. *The Art Institute of Chicago, gift of Mr. and Mrs. Arthur Wood in memory of Pauline K. Palmer, 1859.47.*

In January 1865, Michel contacted his wife and daughters to return home.[38] Before they departed, Edgar painted their portrait,[39] *Mme Michel Musson and Her Two Daughters, Estelle and Désirée.* Perhaps he did so to amuse, distract and comfort them. The portrait captures women steeling themselves for a return to a city ruptured by war.

It was a bittersweet goodbye, so full of sadness and longing that Edgar's cavalier brother René, always an enthusiast, pledged to follow the Musson ladies to New Orleans.

Didi wrote to her father about charming and determined René:

> *He has only one idea, and that is to leave his father's banking firm to go to work and live with us; he says if he stays in Paris, or if he goes to Naples* [to work for the branch of the family bank there], *he will wait for 50 years, earning 30 francs a month; this revolts him....He would rather...be his own master in all things; and to make a fortune from life.... However ardent to attain his goal, he will have to speak and reason a lot before obtaining the consent of his father....Edgar is the only one who encourages René, because he knows all that he suffers from his position, with perhaps no future.*

So ambitious, would René attain success in New Orleans? His father and his Uncle Michel weren't so sure. René wrote Uncle Michel, "Willy nilly, you will see me arrive there & then you will make me into what you wish, a cotton planter or a wholesaler."

René was like a dog after a bone, stating:

> *In short, I am more decided than ever to go to work with you & when we can chat in person you will see that I have done perfectly well to make this decision. Edgar, who knows the family, said it well when he told me that if I want to become something I must completely detach myself with respect to advantage and depend on them only with respect to affection. He is distressed to see me go because we love each other a lot but he well understands that I will find my life over there rather than here.*

Probably as Edgar watched them all leave, the notion of going along tormented him. He had never visited the land of his mother, although he had no doubt heard marvelous stories of the lavish magnolias, camellias and grand swaying palm trees.

We wonder if Edgar didn't have some longing to follow the women to the land of his mother and protect them. But as an artist, an observer, an intuitive, he probably felt all was not well in New Orleans. Indeed, it was far worse there, and despite all, something would make Edgar's mind go *tilt, tilt, tilt,* and he would find himself "walkin' to New Orleans."

Chapter 3

FRENCH BOYS GO TO NEW ORLEANS

Love pulled René to New Orleans. Love for a woman, love for family, love for adventure. René, motherless for most of his life, found comfort in the arms of his cousins and favorite aunt Odile. He said, "When one is near her, one feels oneself loved, so that for me, who never had a mother to caress me, I am double happy to be coddled in this way." Loves were lost, but loves could be found.

Estelle mesmerized René with her soft gaze, lavish dark hair and reddened lips. She was only two years older than him but moved with a youthful grace. They fell in love, and against the advice of both of their fathers, Estelle, twenty-six, and René, twenty-four, married.[40] So determined were they that they got a special dispensation from the Catholic church, which opposed the marriage of first cousins.

René was a rebel and wanted to be like his grandfather Germain, who had sought a wife and a fortune from cotton in Louisiana. But the stars weren't aligned for René. He had absolutely no experience in cotton, other than one bad investment in London,[41] in which he had squandered money entrusted to him by his father, losing $8,000.[42] "Ça n'est pas gaie."[43] René's luck was running out.

René wrote, "America is the country for young men with nerve." He had nerve, but did he have knowledge? His brother Achille also moved to New Orleans, and they soon established an import-export firm, the De Gas Brothers.[44]

Notre Dame, N. Orleans, by S.T. Blessing, 1872. *Library of Congress Prints and Photographs Division, Washington, D.C.*

Both brothers were reckless with love in New Orleans. Soon, they would have flagrant affairs with married women. They enjoyed doing dangerous things in their personal lives. They had secrets that scarred many others— secrets that Edgar would discover in Louisiana.

Making money in New Orleans was precarious at best. The cotton[45] and import-export businesses were failing. René had been raised to charm; he hadn't been raised to work. A desperate dreamer, he needed Edgar's help.

René likely camouflaged his dire circumstances as merely temporary. He fed his French relatives pretend "happy" stories of Louisiana to secure more funding.[46] On one of his periodic trips to Paris, he worked his magic, convincing Edgar to return with him to New Orleans, perhaps by glamourizing the legacy painters like John James Audubon. Surely, Edgar missed his brother, and probably René played on that lost love.

And Edgar was ripe to be charmed. For seven years since his brothers had left France, he'd retreated into himself, backstepping into his art. He abandoned pretensions of the aristocratic-sounding De Gas name and reverted to the original spelling: Degas.

Now, Edgar was in his late thirties, alone in Paris with his brooding father. Loans to his American family and investments in Confederate bonds had strangled the De Gas family's banks. Auguste, bereft, may have needed Edgar to check in on the finances in person and bring his brothers back with him. Couldn't Edgar travel there and just paint on the side?

Edgar appreciated the difference between deeply planned and executed work and self-congratulatory dabbling.[47] Restless, he hadn't yet landed on his own style. Perhaps going to New Orleans could appease his father. He could also assist René, Achille and Uncle Michel. He wasn't heartless to his family's finances; he was just driven by a stronger purpose as an artist. Edgar could paint while he was there; he didn't have to give up on his art.

A bachelor, Edgar mused about seeing New Orleans for himself, having his own family one day.[48] Did it sting that his baby brother already had a family, and he had no one? Virile René and Estelle had had a child every year since they got married: Pierre in 1870, Odile in 1871. And now Estelle was pregnant again. Wasn't it about time Edgar met his new nieces and nephews? Jo, the baby he had sketched in France, was already nine years old.

There were hints that all was not well in New Orleans. Aunt Odile (who had been revived in France) had died from Bright's disease; cousin Mathilde had buried her infant son;[49] and Estelle, now pregnant with her fourth child, was going blind. Did elder and wiser Edgar sense something else was wrong in New Orleans? Did he intuit that René was lying, knowing how slippery he was? Were things going that well, *really*?

There's a strange, deep love for family in New Orleans. Maybe it's due to the violent, precarious climate inside that pocket at the foot of the Mississippi. People are always looking to draw close and protect each other.

New Orleans had come to France, and now France would come to New Orleans. Edgar could no longer resist the magnetic pull of family. Onward to the Crescent City to live, to paint, to seize hope.

Chapter 4

SHATTERED EXPECTATIONS

ONBOARD THE *SCOTIA*

Edgar's name can be found on the passenger list of a paddle steamer from Liverpool, the *Scotia*. Onboard, he amused himself by sketching figures in different angles on De Gas Brothers New Orleans letterhead. But he had to be discreet when he jotted down a note or image of what he saw; postwar, people were hypersensitive and easily offended.

We imagine the scene looked like this:

It was October 12, 1872, and Edgar was on the Scotia *transatlantic passenger ship, headed from Liverpool to New York. The constant motion of the ship beckoned a sense of adventure, and the beautiful ocean scenery invited reflection. He had been looking forward to this trip for twenty years.*

Edgar stood by the rail on the deck. He was dressed neatly in a smart earth-brown vest, a plain frock coat with a turned-down collar and wide cuffs. His hair was slightly thinner with some gray; he had a neatly trimmed beard.

As Edgar watched the water, the glare made his eyes burn. He dabbed them with a handkerchief, sat in a shaded area and observed the passengers. He hoped his eyes weren't worse. If only he could paint a few landscapes.

He rolled up his sleeves and took out art materials, then began drawing on a sheet of De Gas Brothers letterhead. Edgar made rapid sketches of a

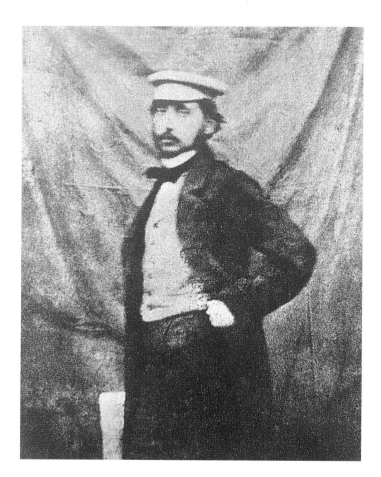

Photograph of Edgar Degas taken in New Orleans, 1872. The original photograph of the artist has been lost. *Special Collections, Tulane University.*

female and two males he observed, capturing the three distinct poses of the figures with rapid and fluid lines. He remembered what his mentor, Ingres, had told him: "Draw lines, lots of lines." That's what Edgar would do without stop in New Orleans.

But barely had Edgar begun when René, charming and dashingly handsome, entered the deck and took a seat next to him. Edgar hoped his brother wouldn't want to talk or dine too much.

René had a chiseled face, full lips and wavy, dark brown hair. He was dressed for an evening out in haute couture, with a fitted navy frock jacket and expensive soft leather boots. He wore a silk cuffed chemise with gold cufflinks.

Edgar needed seclusion to draw. This no one seemed to understand. He momentarily looked up at his younger brother, smiled and then returned to his drawing. Edgar hoped René would see how busy he was. But René

craved distraction, and so he took out playing cards and tried to get Edgar to join. Edgar declined, still sketching. Bored, René looked at his pocket watch and then loudly shuffled the cards and began playing Solitaire.

"Ahh, the graaande artiste, you must take a break and play," René goaded.

Edgar wasn't going to start this trip with an altercation about his obsession with painting.

They were sailing to New Orleans, the epic land of their late mother, the land of bayous and wide-limbed oak trees, that she had perhaps described to him before her untimely death when he was just a teenager.

Edgar spoke very little English and was uncomfortable with so many strangers, so René, a frequent Atlantic traveler, guided him during the ten days of their voyage. Edgar explained, "I knew neither English nor the art of traveling in America; therefore, I obeyed him [René] blindly. What stupidities I should have committed without him!"

On October 23, 1872, the brothers arrived in New York City tired but excited. New York was thrilling, with its brilliant architecture and intense residents hurrying to be at the center of something. It was the art capital of America. Could Edgar remain longer than thirty hours in New York, put off getting on the train headed south? No, his journey had another goal: to reconnect with his mother's people and capture a love that he once knew.

But danger lurked in New Orleans: a spike in yellow fever cases.[50] Was it even safe to arrive there? The brothers created a backup plan to go on to Bay St. Louis, a vacation spot on the Gulf of Mexico, if they had to. The telegraph they were forced to send to check in on New Orleans' safety conditions ruined the happy surprise of Edgar's arrival.

And so, on a balmy fall day in New Orleans, the first thing Edgar saw when he departed the train at the Lake Pontchartrain Depot station was the reflection of light off his uncle's spectacles. Then, a crowd of family: his three cousins dressed in black, their six children, gloved hands waving. Thankfully, no one looked ill.

Loved ones appeared older, weaker, stranger. Edgar may have noted the resemblance between Estelle and his mother. She was twenty-nine, his mother's lookalike, and now almost the age his mother had been when she died at thirty-two. It was like seeing her ghost.

Estelle, Didi and Mathilde were in mourning for their mother, who had died the year before. Who knew when Edgar bid farewell to Aunt Odile, revived during her visit to France, that it would be his final goodbye? Edgar should avoid talking about bad doctors and disease; the gaping absence of

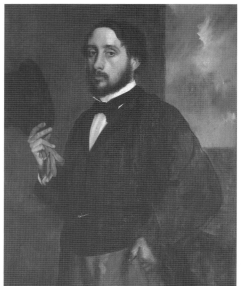 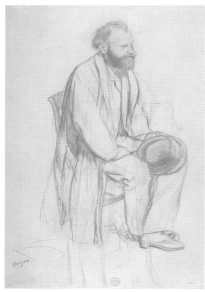

Above, left: *Self-Portrait or "Degas Saluant,"* by Edgar Degas, 1863. *Calouste Gulbenkian Museum.*

Above, right: *Édouard Manet, Seated, Holding His Hat*, by Edgar Degas, circa 1865. *The Metropolitan Museum of Art, Rogers Fund, 1918, 19.51.7.*

Opposite: *2306 Esplanade Ave.*, 2022. This was the Musson and De Gas home where Edgar Degas resided. *Photograph by Cheryl Gerber.*

his favorite aunt said it all. In Paris, there were cures for diseases that killed locals in New Orleans.

The enthusiastic family probably encircled Edgar, so joyful to see him. Then, they boarded a coach to escort them home. They bumped past Gothic mansions with boarded windows, homes diced into boardinghouses, their Greek Revival manors chipped and blurred, showing the wood under their marmoreal disguise. Shutters nailed closed. Overgrown palms and bamboo trees. Edgar was startled by everything he was seeing. This was not the New Orleans of his dreams.

Porches were sinking, balconies drooping with baskets of weeds, banana trees browning with death. Dogs yelped through rotting garbage; death carts clattered by. A bony, mule-drawn streetcar rattled down Esplanade Avenue. No one needed to tell Edgar that crime was up when multiple locks scarred so many front doors.

Looking through the window, Edgar worried that he wouldn't be able to paint outdoors in Louisiana. Painting in sunlight had tortured his eyes ever since he had been hit by shrapnel in the National Guard just a few years prior with his artist friend Manet.[51] Fears of blindness and never painting again haunted him.

The coach slowed down in the French-speaking, immigrant section of New Orleans, and they pulled up to the rental house on Esplanade Avenue.[52] No one dared discuss Uncle Michel's propertied bankruptcy.[53] A lavish repast wasn't waiting for Edgar. What was left of the good china and furniture was in storage; jewelry had been hocked, mementos of the dead and portraits lost.

Inside the home, Uncle Michel may have given Edgar a tour of the grounds, as was the custom when visitors arrived. They scooted past the parlor to the rear of the house, near the kitchen. Whiffs of spicy Creole cooking, like pan-fried rice cooked with green peppers, onions, celery, stock and giblets, could have filled the air.

Moving through an ever-busy household, did Edgar worry about adding extra pressure as a guest? When visitors stayed, rooms were overloaded, the water closet busy and more housework required. And how would he adjust, as he'd been accustomed to living alone as a bachelor?

But the family celebrated Edgar's arrival and embraced him in their loving arms. Of course, they would make room. Looking at Edgar, they likely saw hope, a feeling long foreign.

Death had besieged the family—so many deaths that of the two front parlors in the home, one was reserved for wakes. The room had a side entrance where corpses were carried out; funeral parlors weren't yet a custom. Though death and its rituals were a part of the family's routine, the pain still shook the house.

Could Edgar sense the imprint of mourning in the home, knowing all their losses: the deaths of Uncle Michel's four sons, wife, infant grandson, son-in-law, would-be son-in-law?[54]

Prepared for cycles of illness, recuperation and death, the family home, though jam-packed with eighteen people, still reserved space for a sickroom.[55] As there was so much death and disease, those who could had left New Orleans. Those who couldn't or wouldn't leave mostly stayed inside. Infectious diseases like smallpox ran rampant.[56]

Did Edgar see locals making pilgrimages to the nearby cemetery? Did he feel the sorrow in the alleys of tombs, mostly mausoleums with saints, soaring angels and statues of Our Lady? He may have walked for a nearby visit to St. Louis Cemetery I, where his Musson grandparents were buried.

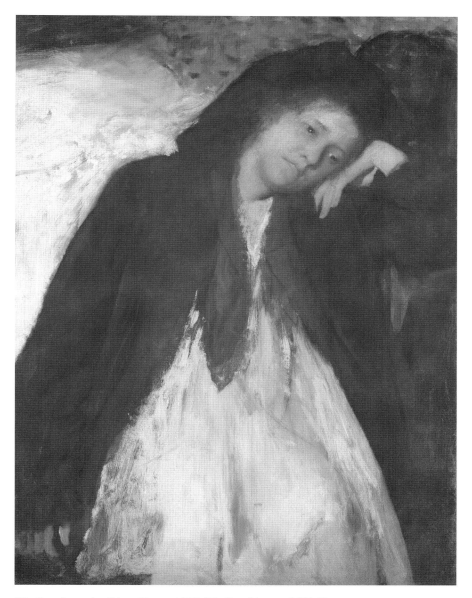

The Convalescent, by Edgar Degas, 1872–87. *Getty Museum, 2002.57.*

Was Edgar surprised by the aboveground graves, a burial process required since New Orleans is below sea level? What did he make of the oven tombs, where new corpses were shoved in front, pushing back the older remains? The family was drowning in death. We imagine it would be difficult for

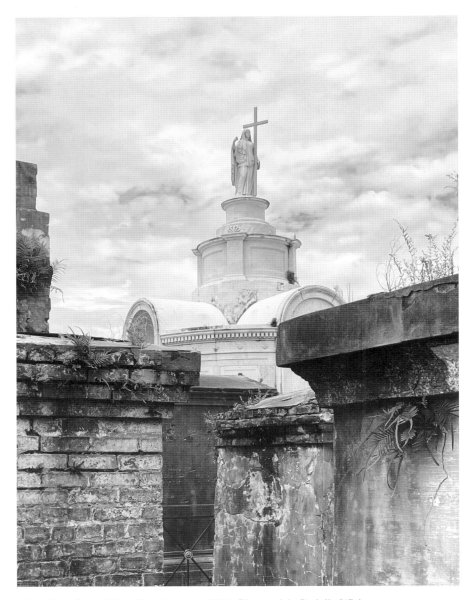

Above: *Above Ground Tomb*, New Orleans, 2022. *Photograph by Rachelle O'Brien.*

Opposite, top left: *Above Ground Tomb with Rusted Cross*, New Orleans, 2022. *Photograph by Rachelle O'Brien.*

Opposite, top right: *Oven Vaults*, New Orleans, 2022. *Photograph by Rachelle O'Brien.*

Opposite, bottom: *Graves under Cloudy Skies*, New Orleans, 2022. *Photograph by Rachelle O'Brien.*

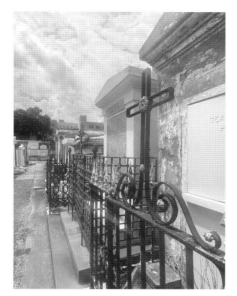

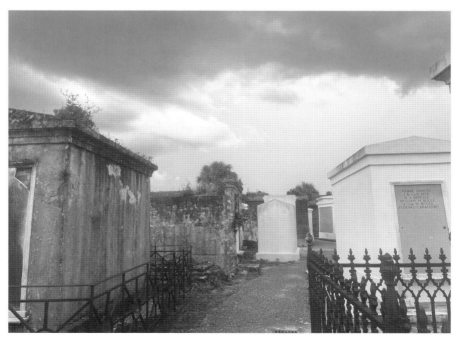

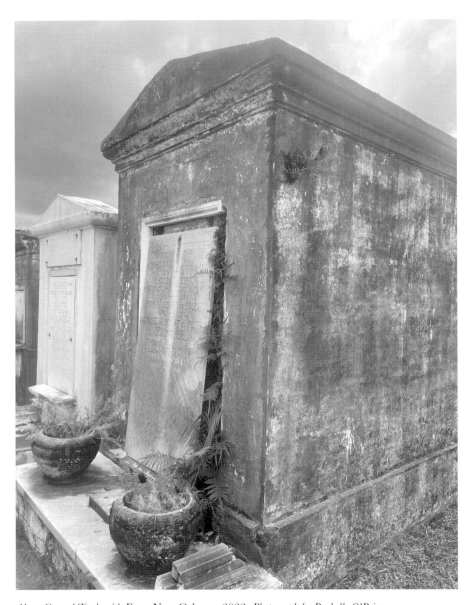

Above Ground Tomb with Ferns, New Orleans, 2022. *Photograph by Rachelle O'Brien.*

Edgar to have an optimistic demeanor with death inside, outside, above and beside him.

So, too, would it have been arduous for Edgar to preserve his focus on painting, as he was a much-anticipated visitor in a brimming home. When he finally was shown to his room, a would-be haven in the back of the house, his heart probably fell as he wondered, Where would he paint? Previously a storage space, this dimly lit, tiny room off the pantry held only a small bed, chest and chair.

The awfulness of his quarters on the first floor prodded him to explore other places inside the house. Perhaps he prowled about looking for places to set up his easel, paints and supplies. Would the existence of a stationary painter monopolizing an indoor area with art supplies heighten the tension?

Taking a break on the front porch, Edgar may have found peace as he breathed in that warm Mississippi River breeze. The gallery would become a haven for painting when glare from the sun or rain wasn't too bad.

Edgar could dry his paintings temporarily on the gallery but was warned that nothing could be left exposed outside for long, for fear of burglary or a deluge. Violent rain could erupt without warning, ruining his paintings.

Sometimes, he would have had to hang his paintings to dry inside a house crammed with nearly twenty people. Indoors, he had to protect his paintings and drawings from the traffic of excited children rushing through, bumping past him. He may have removed their tiny hands exploring his box of pastels or paused before answering their innocent question: What is an artist, Uncle Edgar?

Edgar wasn't sure what kind of art to make. At thirty-eight, that was embarrassing. Who would understand him as an artist? Maybe his brother René would, as he had affectionately called Edgar the "graaande artiste." But then again, René was self-serving and immature, dubbed "l'enfant terrible" by Didi.[57]

Assessing his situation, Edgar may have wondered: Why had he left Paris, his studio, artist and musician friends—Tissot, Manet, Frolich, Dihau—and the controllable routine? He wrote, "Every morning at my brother's office, I await the arrival of mail with more impatience than is altogether fitting." After the mail came, we suspect he quickly left.[58] The first glimpse of New Orleans had likely shaken him. What kind of art could he make there?

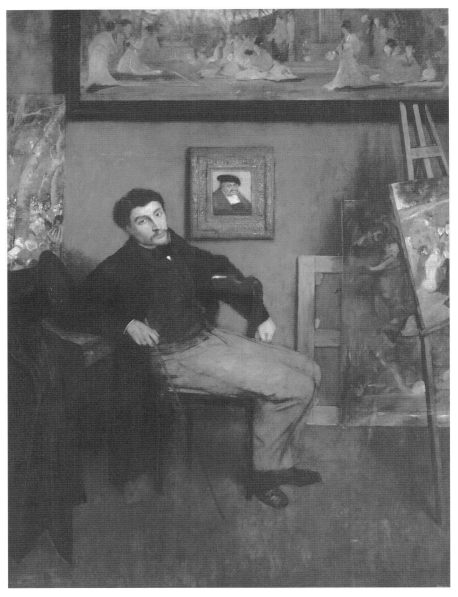

Above: *James-Jacques-Joseph Tissot (1836–1902)*, by Edgar Degas, circa 1865. *The Metropolitan Museum of Art, Rogers Fund, 1939, 39.161.*

Opposite: *Louisiana Jockey Club*, by John William Orr, 1873. *The Historic New Orleans Collection.*

THE HOUSE STUDIO

Edgar wouldn't stay hopeless for long. To sustain the technical mastery he had achieved, he would have to work without cease, drawing endlessly, creating faster and faster.

Edgar carried his sketchbook everywhere, lest he miss an image or remember its rhythm incorrectly. He lasered in on who was the available subject matter for his portraits: his family. He endlessly sketched preparatory drawings, fueled by precision and soul. Meanwhile, neighbors mindlessly barged through doors, children shrieked, red-eyed men stumbled home from the racetrack.

Edgar transformed the entire family home into his studio, provoking compositions in quiet walled-off spaces: on a balcony, in the hall outside the sick room, during a musical rehearsal in the parlor, in a corner where a flower arrangement was being made or where a child was receiving a pedicure.

Edgar found nooks in the house where he could grab a relative in this evermoving household and have them sit for a painting before they ran off. Edgar's cousins indulged him as best they could by posing for his paintings. But he knew they didn't take him seriously. Edgar felt bad about that. Highly frustrated, Edgar found solace in his correspondence with his artist friends in Paris (he had none in New Orleans). He wrote to Rouart, "The family portraits, they have to be done more or less to suit the family

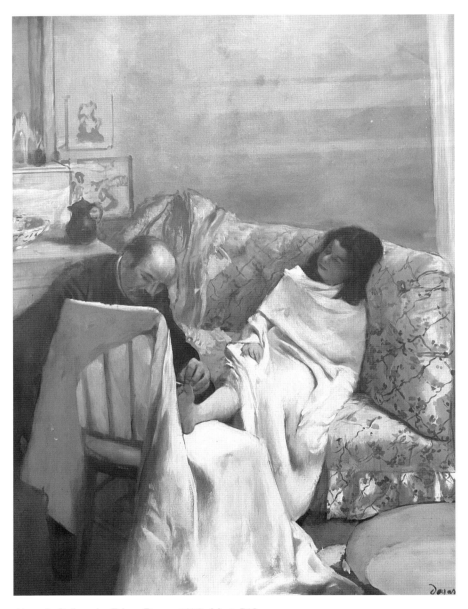

Above: *Le Pedicure*, by Edgar Degas, 1873. *Musée D'Orsay*.

Opposite: *Henri Rouart in Front of His Factory*, by Edgar Degas. *Carnegie Museum of Art, Pittsburgh, acquired through the generosity of the Sarah Mellon Scaife family, 69.44.*

taste, by impossible lighting, very much disturbed, with models of full affection but a little *sans gêne* and taking you far less seriously because you are their nephew or their cousin. I have just messed up a large pastel and am somewhat mortified."[59]

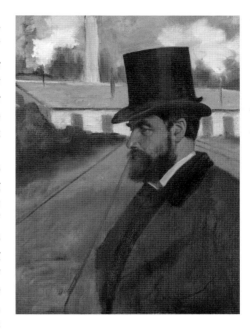

The family likely saw Edgar's artmaking as nonessential, amusing or even frivolous. He may have tried to explain the importance of his tedious, long hours of work, his need to find complexity in painting and why everything was secondary to that. Relatives likely wanted to just show him off, make him laugh, interrupt him or move him from one place to another as more important activities took place. Even today, his great-great-grandniece regrets the fact that her family threw out so many of his sketches from the attic because they didn't believe they were of any value.

At home, in the cocoon of women, Edgar had a keyhole view into the intimate lives of his female relatives. He felt safe with them and welcome to observe their daily women's work. Free to make his art, he sketched at home prodigiously. And sketching at home had another benefit: he could avoid difficult talks about cotton with his uncle and brothers, for which there were no happy answers. Uncle Michel was desperately holding on to a failing cotton exchange operation. Degas wrote, "One does nothing here, it lies in the climate, nothing but cotton, one lives for cotton and from cotton."[60]

Inside behind curtained windows, Edgar kept his focus on his art and painting his family, but it was not easy. He explained, "Nothing is as difficult as doing family portraits. To make a cousin sit for you who is feeding an imp of two months is quite hard work. To get young children to pose on the steps is another job of work which doubles the fatigues of the first."

Later, he shared that he had "wasted time in the family trying to do portraits in the worst conditions that I have ever found or imagined." "A few family portraits," he wrote, "will be the sum total of my efforts, I was unable to avoid that, and assuredly would not wish to complain if it were less difficult, if the settings were less insipid and the models less restless."

Above: *Window on Saint Phillip Street in the French Quarter, New Orleans*, 2017. *Photograph by Robert Schaefer Jr.*

Opposite: *Woman with a Bandage*, by Edgar Degas, between 1872 and 1873, oil on canvas. This painting features Edgar's cousin/sister-in-law Estelle Musson De Gas. *Detroit Institute of Arts, bequest of Robert H. Tannahill, 70.168.*

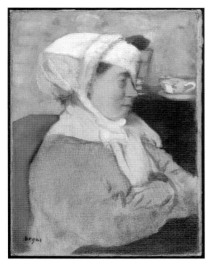

Whether understood or not, Edgar persisted in creating art. Nearly forty, he had developed the rigorous habit of drawing for hours on end, even when he didn't want to.[61] While René was having a mint julep on the veranda, Edgar was likely cleaning his brushes and planning his next portrait, which he hoped could spark delight or momentarily decrease sorrow. He was looking for the beautiful, the positive, the glimmer of hope, even though it pained him that he couldn't paint outside.

Edgar's eye condition shackled him indoors. "The light is so strong," he told Rouart, "that I have not yet been able to do anything on the river. My eyes are so greatly in need of care that I scarcely take any risk with them at all." He bemoaned, "What lovely things I could have done, and done rapidly if the bright daylight were less unbearable for me. To go to Louisiana to open one's eyes, I cannot do that. And yet, I kept them sufficiently half open to see my fill."

Indoors, Edgar could see that the family's plight was troubling, and living and painting so close, Edgar saw it magnified. Through painting, Edgar peered into the souls of people he loved. There was so much desperation around him, he couldn't escape it.

It probably scared him to see Estelle in a worsening state.[62] He wrote about her repeatedly in the letters he wrote to friends while in New Orleans, describing her to Dihau: "My poor Estelle, René's wife, is blind as you know.[63] She bears it in an incomparable manner; she needs scarcely any help about the house. She remembers the rooms and the position of the furniture and hardly ever bumps into anything. And there is no hope!" Did Edgar envision himself having to one day blindly feel his way around a room?

As Estelle got more accustomed to hearing him set up his easels and paints to work inside the house, she and Edgar might have arranged a sitting. In one pose, she stood by a table, which was filled with a wide brown vase of red gladiolas, white lilies and palms. She nervously arranged the flowers, as Edgar painted her quickly between the grayish tan of the wall and the mossy green of the vase, framing her above those red blossoms. Edgar might have said, "*Portrait of Madame René Degas, Born Estelle Musson*—that's what I'll title this."

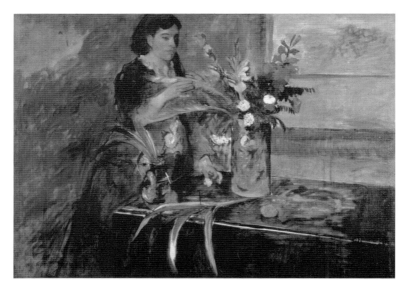

Portrait of Estelle Musson De Gas, by Edgar Degas, 1872. The New Orleans Museum of Art purchased this through public subscription. So important was this painting to the city of New Orleans that a campaign was launched to purchase it. The community effort, "Bring Estelle Home," successfully raised enough funds to acquire the artwork. Even schoolchildren contributed to raise money for this important portrait. This is the only artwork that Degas created here that found a permanent home in New Orleans. *New Orleans Museum of Art.*

Indoors, scrutinizing the faces of his relatives, Edgar spotted the fine lines on their foreheads and around their eyes. He no doubt sensed a deeper misery they were unable to share. He captured their pain in his portraits to immortalize them. His family seemed to look at him with hopeful, haunting eyes. Maybe they wished he'd come to rescue them from their situation, and maybe in some deep way, Edgar hoped he could.

Chapter 5

THE WOMB OF THE WOMEN'S WORLD
AND PAINTING INSIDE

I n Paris, Edgar lived the life of a carefree bachelor, but in New Orleans, the busy homelife activities of women enveloped him[64]—overwhelmed women caring for an aging parent, infants wailing to be changed and desperate men raging. Exhaustion made up the visceral ongoing-ness, the blood and guts of life there. Tension exploded.

Edgar observed his cousins minding children just barely, managing the house just barely, taking care of invalids just barely. Well-to-do women, educated to ornament, to guide, to enlighten, to manage a home, were coping just barely. Overworked, overtaxed and overtired, they needed help.

René invited their beautiful seventeen-year-old married neighbor, America Durrive Olivier, to read prayer books and newspapers to twenty-nine-year-old Estelle and teach the children music. He also engaged a French nurse, who arrived on a small German boat in November 1872. Meanwhile, in a corner, Edgar was sketching with some paper and a pencil, likely uneasy with much of what he saw.

Edgar watched women scoot about in elaborate Victorian outfits meant to set them on display with the ideal silhouette:[65] voluminous dresses, crinolines, hoopskirt frames and heavy fabrics. At best, women's fashion limited their movement, and at worst, it compressed the thorax, restricted breathing and displaced organs.[66] After he left New Orleans, did Edgar choose to paint females—dancers, laundresses and bathers—in the least restrictive garments in response to witnessing how clothing caged women? Would his future subjects be unrestricted, unrestrained, free to move, free to breathe?

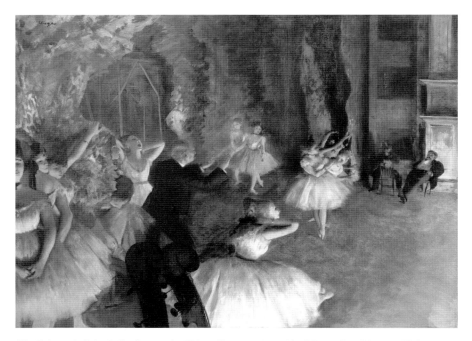

The Rehearsal of the Ballet Onstage, by Edgar Degas, 1874. *The Metropolitan Museum, H.O. Havemeyer Collection, gift of Horace Havemeyer, 1929.*

Living in the rear of the house, right off the kitchen, Edgar was privy to the heartache in conversations.[67] He chameleoned inside the world of Creole women while jotting impressions in his memorandum book. He, no doubt, saw these women on the brink and felt compelled to capture their resilience. He painted a bandaged woman sitting at an ocularist's office (Estelle), women staring out from windowless spaces, women sitting with hands folded, eyes marbleized with woe.

Meanwhile, pain for the men of the household—Michel, René and Will Bell[68]—was acute. They were the providers, and there was no possible way to provide. They avoided shame by burying news of economic disasters and hiding floundering business situations, like René and Achille's company and Uncle Michel's cotton office. The family was nearly penniless. Depression, alcoholism and escapism took hold.

René coped by dallying at brothels[69] in sin city New Orleans, and Will escaped through gambling at the nearby racetracks.[70] Esplanade was a street where you could access both places easily.

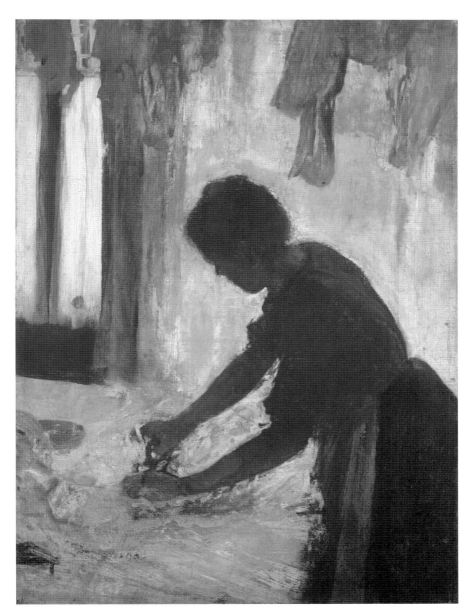

A Woman Ironing, by Edgar Degas, 1873. *The Metropolitan Museum, H.O. Havemeyer Collection, bequest of Mrs. H.O. Havemeyer, 1929, 29.100.46.*

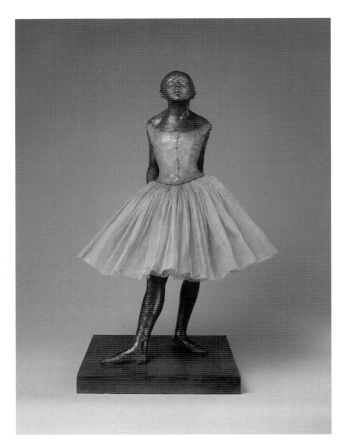

Little Fourteen-Year-Old Dancer, by Edgar Degas, 1922 (cast), 2018 (tutu). *Metropolitan Museum of Art, H.O. Havemeyer Collection, bequest of Mrs. H.O. Havemeyer, 1929.*

Edgar likely saw Uncle Michel, exhausted from searching for new business outlets, turn sour. Perhaps Edgar watched as Michel, Will, Achille and René huddled together with other disgruntled men in private meetings,[71] cursing whomever. Perhaps Edgar noticed them drinking on their porches or releasing anger through long walks. They isolated themselves inside their fears, eyes vacant or pierced with inexhaustible rage. The abundant world they once knew was slipping away, and there was nothing they could do. Anger was currently an acceptable outlet, but inexcusable violence would come next.

Husbands were celebrated for their wealth and power, of which they had none. Wives were celebrated for kindness and selflessness, which were running thin. An interloper, Edgar saw it all. Brothels, secret meetings, gambling and alcohol were not what he'd come to New Orleans for. How did he avoid the pull of deviance? Did he?

EXPLORING NEW ORLEANS

Edgar likely took breaks to escape the eighteen-member household. New Orleans and all its inhabitants inspired him, but he worried he didn't have enough time to capture it all.

He shared:[72]

> *The women are pretty and unusually graceful. The black world I have not the time to explore it; there are some real treasures as regards to drawing and color in these forests of ebony. I shall be very surprised to live among white people only in Paris. And then I love silhouettes so much and these silhouettes walk.*

Edgar was noticing the differences between New Orleans and Paris and already thinking about how this experience would ultimately affect him when he returned home.

New Orleans invigorated Edgar's passion and creativity. He said, "Everything attracts me here. I look at everything I shall even describe everything…accurately when I get back.…In this way, I accumulated plans

Natchez Ferry on the Mississippi River near Jackson Square in New Orleans, 2016. *Photograph by Robert Schaefer Jr.*

St. Charles Hotel, New Orleans, La., 1869. *Library of Congress Prints and Photographs Division, Washington, D.C.*

which would take 10 lifetimes to carry out. In 6 weeks' time, I shall drop them without regret in order to remain and never more to leave my home."

Edgar wrote, "I want nothing but my own little corner where I shall dig assiduously. Art does not expand, it repeats itself. And, if you want comparisons at all costs, I may tell you that in order to produce good fruit, one must line up on an espalier. One remains thus all one's life, arms extended, mouth open, so as to assimilate what is happening, what is around one and alive." He took it all in.[73] New Orleans was thrilling, full of highs and lows, but it remained awe-inspiring.

Edgar was likely impressed by the beauty of the city when he rode the trolley or strolled in the French Quarter and along the Mississippi River. But even on the streetcar, or under the big-branched oak trees, or along the thrumming river, the glare was too fierce for his damaged eyes. He wrote, "Villas with columns in different styles, painted white, in gardens of magnolias, orange trees, banana trees…with a brilliant light at which my eyes complain." He was devastated that he couldn't paint outdoors.

Like the confined women, Edgar remained indoors, protecting his failing eyes. He shared, "My eyes are so greatly in need of care that I scarcely take any risk with them at all. A few family portraits will be the sum of my efforts."

FAMILY PORTRAITS

All day long, he stayed among his kinfolk, painting and drawing, making portraits of the family. Edgar worked throughout the house, which must have irritated the busy household. He probably begged his bustling cousins to sit for portraits, explaining that as a copyist in French and Italian traditions, he had to sketch unceasingly. Sometimes, they politely obliged. Estelle seemed the most available and open to posing for him.

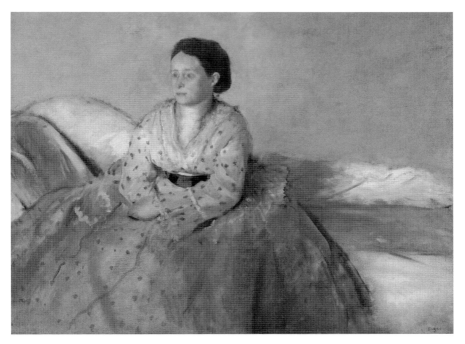

Madame René De Gas, by Edgar Degas, 1872–73. *National Gallery of Art, Chester Dale Collection, 1963.10.124.*

We imagine a scene may have occurred like this:

> *Edgar was working alone in his tiny artist studio in the rear of the house. The weather was bad, rainy and humid. He was running low on art supplies. Still, he worked feverishly on his portraits.*
>
> *The constant devotion to reworking the painting caused Edgar to sweat. He tried to cool himself off by unbuttoning and fanning out his chemise. Edgar noticed it was hard to breathe. He sat and caught his breath, closed his eyes to calm his nerves.*
>
> *Suddenly, as if realizing something, Edgar opened his eyes and begun furiously racing around the room, searching for something. Under a chair, beneath a book of Renaissance drawings by Michelangelo, Edgar found a burnt umber paint tube. He picked it up as if he'd found a bar of gold. Paint supplies were so expensive and hard to find in New Orleans.*
>
> *Somedays, Edgar walked to the window and propped it open with discarded ledgers. A fly, cockroach, mosquito or caterpillar might have crawled in. Then a sudden downpour of rain.*

A knock. When Estelle entered, Edgar's face lit up. He quickly removed stacks of incomplete sketches of horses and landscapes from the chaise lounge and gestured Estelle to sit. He jetted to his easel to continue his painting of her. Estelle blushed. She coyly readjusted her body to maintain the original pose of the painting.

He sketched Estelle's beautiful face lost in thought, holding fragility and a slight yearning. While drawing, his face held some tension, and his eyes started to water. He fought to tolerate this disturbance, and lack of light made it difficult to paint.

Edgar's right eye streamed tears. He quickly dabbed his eye with a handkerchief and admitted, "My right eye is worthless." Then, he suddenly panicked and said, "What if—I lose the other eye? My God. If I woke up blind, I couldn't face it."

With sorrowful, honest eyes, Estelle might have said, "You'll create anyway. Vision comes from inside."

Just then, the door was thrown open, and René De Gas sauntered in. He was dashingly handsome and walked with a sense of confidence that showed an inflated ego with a touch of narcissism.

René took Estelle's hands and spun her about. She feigned happiness. Edgar dropped his paintbrush, all color drained from his cheeks. He slowly backed away from the happy couple until his boots hit the wall, and he felt himself literally and figuratively trapped, an unwilling witness to married life.

Edgar could escape and grab a breath of fresh air on the balcony. This became another perfect setting for a portrait. It was a protected private-public space,[74] an escape for Creole women. Sitting on the balcony, his Creole cousins could watch the world go by from a safe distance. They could grab fresh air, get away from noisy children or have a quick cry.

One day, Edgar captured his cousin there. Mathilde resembled Estelle. After all, she was the cousin with the light eyes, the soft gaze, the gentle nature whom Degas was sensitive to.[75] Her dark hair swept up, her neck exposed, cool, seductive. A black choker offset her delicate peach-toned skin. She glowed, fanning herself, keeping her azure eyes on Edgar, lips upturned in a slight grin. For an instant, she hadn't buried one infant, wasn't nursing a newborn or appeasing a child yanking at her skirt. She was not fearing the next childbirth, in which she indeed would die.[76]

Mathilde couldn't pose for long. When not feeding an infant, she was doing relief work for the families of the dead and the wounded from the

Lower Garden District (balcony). *Photograph by Cheryl Gerber, 2022.*

Left: *The Artist's Cousin, Probably Mrs. William Bell* (Mathilde Musson, 1841–1878), by Edgar Degas, 1873. *The Metropolitan Museum of Art, H.O. Havemeyer Collection, bequest of Mrs. H.O. Havemeyer, 1929. 29.100.40.*

Below: *Woman Seated on a Balcony*, by Edgar Degas, 1872. *Ordrupgaardsamlingen Museum.*

Opposite, top: *Degas Drawing of a New Orleans Cousin (Estelle or Mathilde). D'Orsay Museum library. Photograph by Rory O'Neill Schmitt, 2022.*

Opposite, bottom: *Degas Drawing That Identifies Estelle, Musée D'Orsay library. Photograph by Rory O'Neill Schmitt, 2022.*

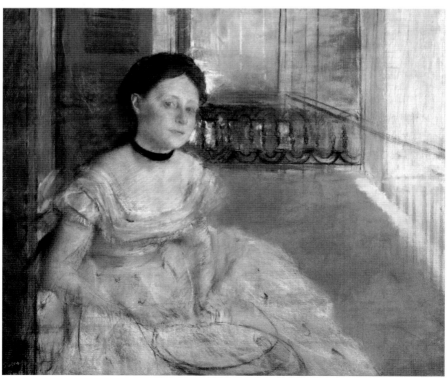

319.

1873 Mme RENÉ DE GAS. (Estelle Musson.)
Pastel sur carton. H. 0,63. L. 0,57, signé en bas à droite et daté 1873.
 Expositions : *Masterpieces by Old & Modern painters*, Knoedler Galleries,
 New-York, 1914; Grolier Club, New-York, 1922, N° 109.
Voir : H. O. Havemeyer Collection, p. 128 *(repr.).*
Esquisse pour le N° 318.
 Cf. les N° 305, 306.
Collection Edmond Taigny, Paris. Collection H. O. Havemeyer, New-York. Metropolitan
Museum of Art, New-York (Donation Havemeyer).

LE MOISNE 1348

war, the bloodiest in American history.

Edgar would return to paint Estelle; she was so kind, cheerful and obliging. Edgar became more and more drawn to her. Of all the cousins, he painted her the most.[77] Perhaps, their crisis bonding in France reignited itself in the close-up portraits he did of her inside the house. Creating portraits was time-intensive, and posing a model was an intimate experience. Edgar may have tested various positions, folded Estelle's hands like a little doll's, lifted her chin, adjusted her shoulder, neck, cheek.

Because of her blindness[78] and pregnancy, Estelle was available to sit in some walled, cornered space. She wouldn't run off scattered and busy. With Estelle, he could have shared his unspoken terror of going completely blind. With dear Estelle, Edgar may have found commonalities: she, too, avoided the sunlight. She, too, sought out the cool shadows. She, too, fought back despair.

Estelle's deep, sightless eyes held a pain full of inner seeing. Contemplative, she was the perfect model in an otherwise unruly household. Was she also troubled about finances? Her daughter's orphan pension fund was being reviewed.[79] And when Edgar

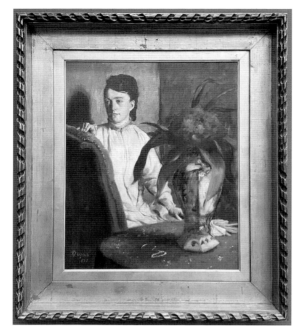

Left: *Woman with a Vase of Flowers*, by Edgar Degas, 1872. *Musée D'Orsay*.

Below: *Children on a Doorstep*, by Edgar Degas, 1872. *Ordrupgaardsamlingen Museum*.

Opposite: *1222 Tonti Ave.* (America and Leonce Olivier's home). *Photograph by Cheryl Gerber, 2022*.

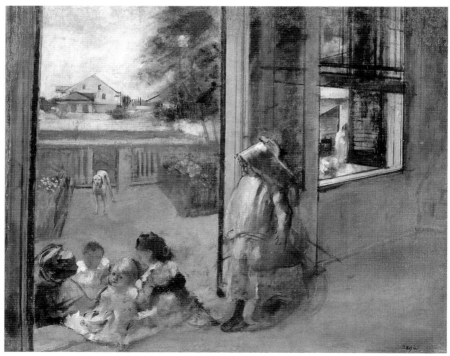

arrived, Estelle was in her third trimester; baby De Gas was due around mid-December.

But the pregnancy was shrouded in secrecy for some untold reason. In December, just a few days prior to the baby's birth, Edgar wrote that Estelle was "blind but has mastered her misfortune. The third child is on the way. I shall be its godfather, but it will not have my obsession. But this is a secret even though the date is the 15th, do not mention it to anyone; we do not speak about it to anyone. I am not even writing about it to my sister. This is an order. Papa wishes the world to end just as if we were not there to make order in it." What did Edgar and the family fear? What had to remain unspoken?

Edgar studied Estelle when painting her, through the silences, the avoided conversations, the stolen glances. He watched her through what was said and not said, inside the music that soared from the piano that the married neighbor, America, was playing in the parlor for music lessons.

Artists are perceptive, and Edgar might have seen the dynamics of the house shift when visitors arrived. For instance, America, now pregnant, was spending more and more time at their house. Was she the cause of worry behind Estelle's eyes, or was it some other concern?

Edgar may have cringed when he observed the communal space between Estelle's home and America's camelback house.[80] Back doors swung open,

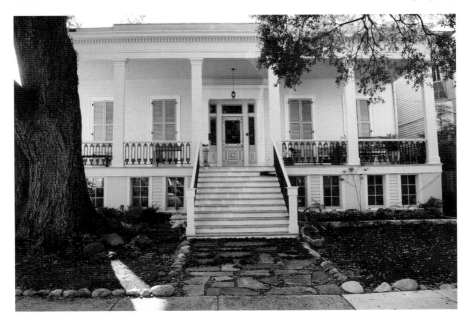

and children, adults and even a dog sauntered back and forth. America's home was almost an extension of René's.

Curious, Edgar set up work inside, near the doorsteps into this courtyard, and began sketching as his nieces and nephews flopped down on the steps with the nurse. He had to paint quickly before mishap overtook them.[81] Little did Edgar know that four of the children whom he painted would eventually die of yellow or scarlet fever.

Edgar placed René's white Catahoula hound, Vasco de Gama, guarding the courtyard gate to America's.[82] It was odd how the dog ran freely between the houses, equally at home in both, standing guard, looking directly at Edgar. Was the hound warning Edgar? In the painting, Estelle and René's youngest child, Odile, looked up at her uncle Edgar with bright blue eyes, seemingly asking for answers.

We surmise that something wasn't sitting quite right for Edgar. What disaster did he foresee? And was there anything he could do to help? Edgar kept delaying his travel plans back to Paris.

Perhaps he heard music in the front parlor and felt a knot tighten in his stomach. Could Edgar have ever caught his brother? A duet was being played, two people sitting down together on the piano bench, hands crossing over, counting out loud together, legs touching when pedaling. But it wasn't the children in their lesson. It was René playing with America.

Chapter 6

BETRAYAL AND SECRETS EXPOSED

Music Seduction

Edgar had sensitized himself to music. As a boy, he reveled in the songs of his mother, an amateur opera singer. Might Edgar have recalled how music touched his heart? Célestine's distinct operatic voice was so rooted inside his memory, lifting him, like the melodious voices in the Café Chantant and the Paris Opéra. Resonances probably connected him to a deeper world, full of all things beautiful.

New Orleans had forever been a town of music, with dance parlors and street singers, local sounds of thrumming rain and wind. And now, within the family home, America, the music teacher, probably ensconced herself at the piano like a rock.

Of course, Edgar was forced to hear her playing, since she was downstairs center stage,[83] so to speak. The parlor was the performance space and the gathering area in the home. And since New Orleans theaters, symphony and operas were closed,[84] musical standards had plummeted, and even the most miserable performers were likely passing themselves off as geniuses in family parlors. Did Edgar intuit something wasn't quite right when he repeatedly saw the rouged seventeen-year-old neighbor with her delicate hands perched on the keys?

While America was the music teacher,[85] Estelle, twenty-nine, was the overtaxed student. Estelle likely rehearsed lyrics[86] with difficult scales to achieve the right effect. Apparently, Estelle needed to be taught that her

French Opera House (New Orleans), by Marie Adrien Persac, 1859–73. *The Historic New Orleans Collection.*

pitch was off, needed to be shown the desirable way to stand, needed to hear the correct way to hit that high note. Learning how to sing required vulnerability and, sometimes, outright humiliation.

We envision a music lesson and song rehearsal might have gone something like this:

> *Estelle entered the parlor, approached the grand piano and removed sheet music from the piano bench. When no one was looking, she held it very close to her eyes and then sat and played "Mon Ame à Dieu Mon Coeur a Toi!"*
>
> *She fumbled in the first few bars as America entered and stood behind her. America placed her hand on Estelle's shoulder, and Estelle slightly recoiled, but still she went on, decreasing her pace but playing more skillfully, by heart. "That's better," said America.*
>
> *America told her not to worry about the children; she had handled everything: supper, baths, bedtime reading. René would say their prayers with them.*
>
> *When Estelle went to thank her, America cut her off, saying that the kids hadn't asked for her. There was a noise down the hallway. America looked about critically, intensely for someone. She fluffed up a limp pillow.*

Estelle continued to play the piano.

America said, "You're doing slightly better. Don't forget what we talked about." Estelle nodded.

René entered the parlor from the kitchen, eating a biscuit, smiling proudly as he saw the two beautiful women. He crept over to Estelle, leaned over and sweetly kissed the top of her head, then waved awkwardly to America.

America struggled to get more attention: "Shall we sing our song, Estelle?"

Estelle replied, "But I was just start—"

America pulled Estelle up to stand, and she found two copies of the sheet music, "Der Hölle Rache from Mozart's Die Zauberflöte," and handed one to Estelle. America said, smiling at Rene, "This opera is one of René's favorites."

Estelle warmed up her voice. She had had some professional training.

René took a seat at the piano and likely accompanied the two anxious women's rehearsals. He was an excellent pianist and, like Edgar, adored music. From the piano, René watched the women with an excited voyeurism.

Edgar was passing by and watched from the doorway. He began sketching, inspired by some complexity in the air.

Edgar captured the painting *The Song Rehearsal* behind closed doors. He didn't wield a sword; he held up a mirror. Estelle shielded her eyes from the light, almost blind and leaning away. Meanwhile, America, mouth gaping open, sang with confidence, demanding attention. Romanticism prevailed at the time, stressing the importance of the emotional in art. Did Edgar, the family's Raphael,[87] capture the invisible notes of the song traveling through the air from America to Estelle and René?[88]

Or was Edgar saying "beware" through his painting? The mistress is in the house. Admittedly, intuition wasn't proof that his brother was doing anything wrong, but an artist's hunches have proven to be correct more often than not.

In the artwork, America lifts her arm in glory, while behind her head, a tropical plant forms menacing, Medusa-like snakes. Perhaps Edgar saw disquiet cross Estelle's face and noticed her cringing toward her husband, a seated blur behind the piano. Was René turned on? Or was he utterly confused, torn, lost?

In this fierce time, many men couldn't connect with any more needs, and many women went about with pasted smiles and prayers. America was the mistress of the piano, and she ultimately became the mistress of René.

Perhaps infidelity became a way for René to be doted on while not having to give up a partnership with Estelle that still meant a lot to him. He might have been in real pain before he decided to cheat on his wife, both from the

The Song Rehearsal, by Edgar Degas, 1872–73. © *Dumbarton Oaks, House Collection, Washington, D.C.*

neglect he was facing and the realization that his marriage would never line up with his expectations.

René had no money, and he was stuck in New Orleans with a bitter and broke father-in-law and his blind cousin-wife, who was about to give birth in December. Life was drowning in too many worries, with the rise of insurance premiums, crash of stocks and threat of death for two pregnant women he cared about. America's baby was due in late February 1873.[89] Did René father both children? Infants were bursting into the De Gas world haunted with threat of disease and, perhaps, questionable parentage.

Edgar knew that René had been a spoiled child who needed constant attention and affection. He had always gotten everything he had wanted. René's proximity to America might have made Edgar uneasy.

THE BIRTH

Tension mounted as Estelle's due date approached in late December. Cities like New Orleans were infant slaughterhouses, or abattoirs. Poor infant feeding practices, sanitation, water supplies and methods of waste disposal led to infection and death. The early years of life were referred to as "fatal years," with one-quarter of infants dying in their first year of life.[90] Tragically, Estelle would come to bury four of her six children.[91]

Mothers fared little better than their children. Of all the ways women met their death, giving birth was the most common.[92] This would be Estelle's third year in a row of having a baby.

Childbirth was an agonizing and perilous experience at home, with no anesthetics.[93] Edgar was living in the house when Estelle went into labor. What thoughts plagued his mind as his dear cousin was helped up the thirty-two steps to her bedroom to start the childbirth process?[94]

Once labor commenced, men were barred from the room. Likely, Edgar absorbed the anxiety of his uncle, aware that he had buried four sons and one grandson. It must have horrified Edgar, hearing Estelle's screams, as well as doors banging and women running up and down the stairs to get water. He probably knew that if bleeding started, nothing could stop Estelle from bleeding to death.[95]

Estelle and her wee daughter, Jeanne, survived the birth experience on December 20, 1872. Would they make it through the next imperiled month? Many didn't.[96] Edgar experienced life up close and dangerous in New Orleans, creating the haunting paintings *The Convalescent* and *The Sickroom*.

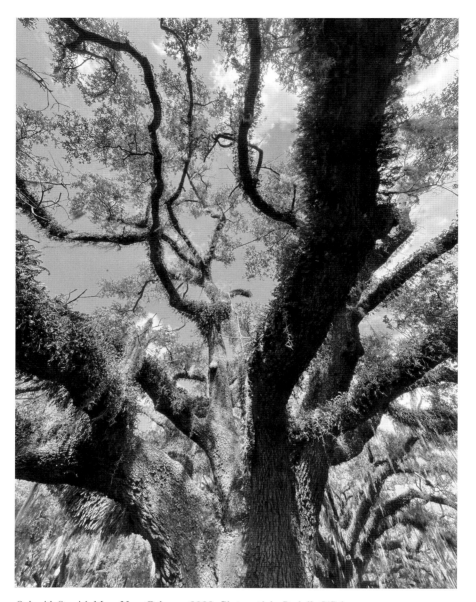

Oak with Spanish Moss, New Orleans, 2022. *Photograph by Rachelle O'Brien.*

LIFE WITHOUT HIS MUSE

As was the custom, Estelle isolated for the month following her baby's birth until the baby's baptism, where Edgar would be the godfather.[97] Secluded, she was not privy to anything happening downstairs. Did Edgar see René's increasingly careless behavior, slipping off with America? Or was the betrayal even more outrageous, with René and America having sex downstairs while Estelle was recuperating and breastfeeding upstairs?

January 1873 was a solitary month for Edgar, a month of rupture from his portrait muse, Estelle. No doubt, he worried. Edgar wrote no letters between December 5, 1872, and February 18, 1873, or at least none that survived. His silence about the newborn De Gas and the family cotton firm in his letters probably revealed his own disquiet about the situation.

Perhaps Edgar was starting to see how egocentric René was. Did Edgar reflect that he'd prefer to be alone in Paris rather than sharing life in a house where the innocent, gentle ones suffered? At home, Edgar saw their world was collapsing, but outside at City Park and in the cotton office, he found it was far worse.

Chapter 7

COTTON CRASHES AND RAGE RISES

Dueling for Honor

Amid disease, death and economic collapse in New Orleans, rage ignited. Violence in the form of duels became commonplace. More duels were fought there than in any other American city. Prominent New Orleanians battled in City Park, which was just down the street from Edgar.[98] Edgar no doubt knew this park, 1,300 acres in size, as it flanked the left end of Esplanade Avenue and was close to his house, only one mile away.

Rituals of honor, these fights to the death exploded over real and trivial insults and were fought with pistol, saber, bowie knife, long sword and even poison pills. Some were deliberately provoked by men anxious to display their skill. Others burst from the heat of the moment.

In fact, after one distressed argument, Uncle Michel challenged Mortimer Wisdom, a member of the White League, to a duel. Uncle Michel would grow more and more paranoid, even at one point later threatening to "shoot him on sight" after one altercation.

The Dueling Oaks were a favorite setting for these affaires d'honneur. For decades, sword clanged against sword and bullets streaked between these ancient trees in City Park that still stand.

Another renowned tree was Suicide Oak, so named for its low-lying branches where men hanged themselves. Within twelve years, sixteen men died by suicide by hanging under its branches.[99] Unable to cope with the heightening depression and financial crises, men committed violence toward

Right: *Bridge in City Park*, New Orleans, 2022. *Photograph by Rachelle O'Brien*.

Below: *Dueling Oaks*, New Orleans, 2022. *Photograph by Rachelle O'Brien*.

Suicide Oaks, New Orleans, 2022. *Photograph by Rachelle O'Brien.*

Saint Louis Cemetery #1, New Orleans, 2016. *Photograph by Robert Schaefer Jr.*

themselves. Some considered hanging, a simple suicide method that didn't require complicated techniques, an honorable way to die.

Yet probably what kept Suicide Oaks from being overused was the high percentage of Catholics in New Orleans. Those who killed themselves were unable to be buried on sacred ground or receive a funeral Mass, as the Church taught self-murder was a sin against God.[100]

What did Edgar make of the viciousness, the horror, the mounting anguish in the city? Did Edgar ever witness a procession to these oak trees or see a man being carried away, perhaps to his family for burial? Did he fear that he or a loved one would be next?

Edgar was likely shaken by the violence. And as a foreigner, he probably felt heightened uneasiness. He had to be careful what he said and to whom.

EDGAR AND THE COTTON OFFICE

When he first arrived in New Orleans, Edgar visited his brothers' office daily.[101] Whereas City Park was to the left end of Esplanade, the family offices were to the right. He'd make his way by mule-drawn streetcar or by foot along Esplanade Avenue and across the French Quarter to Factors Row in the commercial district.

He likely arrived in New Orleans believing it could soon become again a major wealthy city of the South, a port rivaling New York in trade.[102] In his letters, he wrote that he was proud of his brothers and their success. Edgar often visited Achille and René's office, De Gas Brothers, at 3 Carondelet Street,[103] where he'd check for mail, respond to letters and read the local newspaper, trying to keep track of what was happening back in Paris.

Then, he could have strolled to Uncle Michel's[104] cotton factor office, Musson, Prestidge and Company, Cotton Factors and Commission Merchants. It was nearby, among a suite of handsome red-brick buildings at 63 Carondelet Street. It all sounded romantic, right?

But the pavements on Factors Row were crowded with anxious cotton factors, buyers, brokers, re-weighers, classers, pressers and samplers—all participants in the cotton trade. Nearby, brokers spilled out of the Cotton Exchange, hurrying to and fro, headlong and wary.

The Cotton Exchange was formed in 1870 to save the failing cotton sales. Three hundred factors joined a "union of factors" to get the latest intelligence on new markets and maintain rooms where buyer and seller could meet.

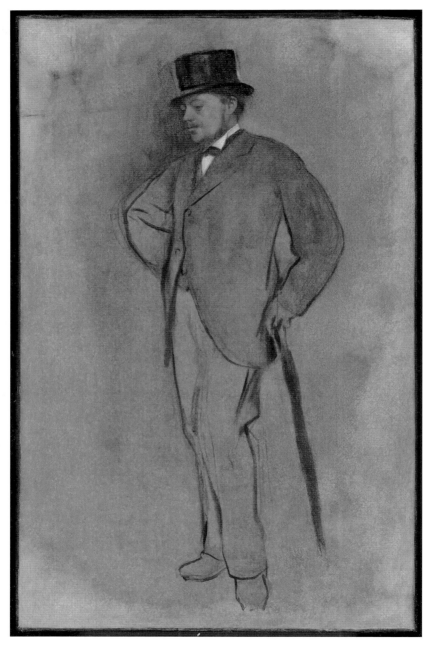

Achille De Gas, by Edgar Degas, 1868–72. *Minneapolis Institute of Art, bequest of Putnam Dana McMillan, 61.36.8.*

Cotton factors, like Uncle Michel, were middlemen involved in financing and marketing the cotton crop. They received the crops and secured credit for their clients. They often worked with brokers, who appraised the cotton.

René was raising money for the Cotton Exchange, as it had cost about $30,000 annually, but now the Exchange was useless—like a bandage on a severed arm. Edgar could hardly walk past the Cotton Exchange without a seizure of alarm.

Desperation was rising. By February 1873, Edgar had already made plans to paint the cotton office and was making preparatory drawings of the hustling modern office where fortunes were made and lost. The Musson, Prestidge and Company firm's instability was reaching a crisis at the same time Edgar decided to paint it.[105]

When Edgar went to his uncle's office, he might have tried to follow the endless concerned chatter in English about fluctuating cotton prices. Destitute businessmen complained, requiring an ear to rattle to, even if the listener understood nothing. Did Edgar notice the strained faces as men waited for the never-coming appropriate response?

Edgar didn't understand how things worked in American finance, or in the family cotton business for that matter, which was driving men to extremes. He probably was afraid to learn. Feigning any interest was like stepping on quicksand. You were sucked into the vortex of hopelessness.

Under such fierce pressure, Edgar likely visited the office less frequently. He probably couldn't bear seeing the sagging faces of colleagues. The office, once quite mysterious and curious, now had a funereal chill, as if preparing itself for rigor mortis. Men like Uncle Michel, Achille and René were figuring out how to stay afloat in a plummeting economy. They faced many death blows: stocks were crashing, disease and death were rising.[106]

We imagine one of Edgar's visits to his uncle's cotton office might have looked like this:

> René toured Edgar around the failing family business. Fourteen men in top hats and suits bustled about. There was a false busyness about the place.
>
> Two workers dawdled about; another worker cleaned his pocket watch. A sweaty and slightly bald accountant wrote up financial books, repeatedly coming up with the same disappointing figure. René gestured to Edgar to look at the accounts. Edgar rolled his eyes; René laughed it off.
>
> During René's tour, Edgar intently surveyed the space, selected a space where he could paint and set down his art supplies.

Their paunchy brother-in-law Will Bell eagerly shook Edgar's hand and then returned to inspecting the cotton.

Edgar gestured to the table with his art supplies. He walked to his table, trying to figure out how he would make his composition; he moved three feet in various directions to gain different perspectives. Edgar observed the interactions of the workers, the inventory and the space. He sketched long lines to create perspective of the room. He drew quick movements to show the different postures of the workers.

Uncle Michel approached Edgar, annoyed. "I thought you were coming over to look at the books." He stormed off.

Edgar continued, silently drawing the space. His face was haunted with inspiration.

Later that day, Edgar and René sat outdoors at the nearby Café du Monde in the French Quarter. They drank café au lait and ate beignets doused with powdered sugar.

René looked up at Edgar forcefully. "You can't paint the cotton office like this."

Edgar reassured him, "I'm going to gloss it over so it won't look so bad. I'll paint the cotton office with a patina of happiness."

FINANCIAL PANIC AND THE LIQUIDATION OF THE MUSSON FIRM

The great financial panic was seizing the world internationally. And in New Orleans, men, already uneasy, fought back their terror as they watched inland markets dominate the cotton business, taking it away from the Crescent City.

The railroad and telegraph were obliterating the cotton industry. Trains replaced ships for cotton transport. Telegraphs revolutionized communication, making in-person meetings in New Orleans no longer necessary. It was disastrous for cotton factors, like Uncle Michel and René. Long the sole agent, banker, storekeeper and confidant of the planter, the cotton factor found himself sidelined. Would they all have to dig their own graves?

How was Edgar to cope with disaster everywhere, distraught relatives, decaying funds? His uncle, already embittered by the federal occupation of the city, confronted banks and businesses facing a financial crash.[107] So many firms had overextended themselves and were declaring bankruptcy that in a matter of months, the New York Stock Exchange would close its doors.[108]

Uncle Michel and René were finished. There was no chance they could pay off the debts they had accumulated. There were no new prospects to be charmed, no more furniture to be sold, no more property to be triple mortgaged. In truth, Uncle Michel's failing cotton business was just a casualty of the bigger crash of the southern economy.

Uncle Michel tried to carry on his factoring business like before the war.[109] Bullheaded, he still believed he knew how to do things the right way. He couldn't accept accountability for any mistakes, even if everyone else knew it. He couldn't imagine himself poor. After all, Michel hadn't made his fortune; his rich father (the adventurer from Haiti) had. Uncle Michel had inherited the golden goose egg. And now, he'd shattered it.

It was sheer madness. Edgar saw the piles of invoices stacking up, cotton prices plunging and diseases massacring the city. The drowning cotton business would never resuscitate.

Then on February 1, 1873, the bank officially announced dissolution, and liquidation of the Musson cotton office was formally announced.[110] Shortly afterward, the dissolution of De Gas Brothers was declared.[111]

Bankruptcy was an unexpected kind of betrayal. Edgar held René liable for mismanagement in New Orleans, at least for his chicanery in how he had presented the situation to Edgar.

René probably couldn't talk about the cotton business; it wasn't open to discussion because, quite frankly, although he was doing nothing, there was nothing he could do. Since childhood, René had preferred to live for the moment and let others handle his personal finances. Edgar and his father had protected him. When René made excuses, they accepted them, replenished his funds and overlooked his shoddy business practices.

René had certainly lost a chunk investing in cotton in England in the past.[112] But did he feel ashamed? Doubtful. He had written to Uncle Michel about the England fiasco: "It is not very lucky for a first start, and a speculation that gave me a little too costly a lesson. I am not saying about it to the family that would only ruin me and at this time. I need all their good graces. I will make up that money sooner or later, but to begin life with debts and to engulf the fortune of my brothers and sisters from the outset."[113]

Painting the Cotton Office

Inside all this tension, Edgar began sketching the cotton office with hopes of selling the picture to a client who was a cotton manufacturer from Manchester.

Edgar was becoming a different sort of businessman than his brothers.[114] In New Orleans, Edgar began transforming into an art entrepreneur and strategic-thinking capitalist.

In February, he told Tissot about his plan to focus his remaining time painting the cotton office because he felt he could commercially benefit. He wrote:

> *After wasting time with my family, wanting to make portraits in the worst possible conditions I have ever encountered and imagined, I set about working on a rather hard painting intended for Agnew and which should do well in Manchester; because if a mill owner ever wanted to find his painter, he'd have to catch me now. Inside a cotton buyers' office in New Orleans.*

Edgar described the cotton office painting with about fifteen individuals and also shared about a cotton merchants painting, "less complicated and more unexpected, and with better craftsmanship, in which there are people in summer suits, white walls, sea of cotton on tables."

He wouldn't have enough time for the paint to dry prior to his departure:

> *With nearly 15 days I plan to spend here, I will complete the painting. But I won't be able to take it with me. To confine a barely dry canvas for a long period of time, away from light and air, as you know, will turn it into chrome yellow number 3. So, I can either deliver it myself in London or send it there only around April.*

Edgar frequently dove into this artwork, silencing his raging heart. He sketched the cotton office vigorously. Did his uncle think Edgar was a lunatic who, even now as things devolved to extreme levels, wouldn't give up his art hobby? How could Edgar paint when men feared they couldn't feed themselves?

Edgar was deeply connected to their pain and was capturing it. The cotton office had seared its skeletal self into his soul. He would create its death mask and cover it with a patina of happiness.

In this painting, Edgar depicts men in sober business activity, including his family members. Uncle Michel inspects a recent cotton sample, pulling it taut, while Will shows a handful of cotton to a client. Meanwhile, oblivious René scans the *Daily Picayune* (which announced their liquidation) and smokes a cigarette. Achille, in a top hat, leans casually on a windowsill. Was Edgar saying his brothers were bored,

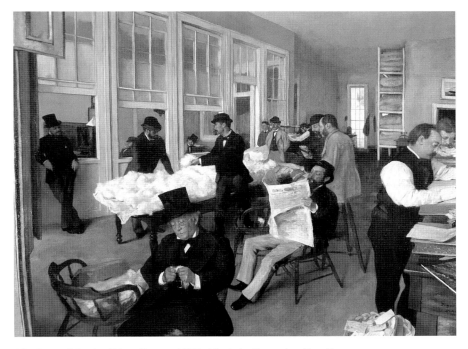

The Cotton Office, by Edgar Degas, 1873. *Musée des Beaux-Arts, Pau, France.*

disinterested, ambivalent, distant, lazy and lethargic because they were helpless?

Edgar immortalized other businessmen, including Uncle Michel's partner, John Livaudais, examining ledgers, and Jason Prestidge, talking to a customer and taking notes. Limp men stand about, going through the motions of a day at the office,[115] averting direct eye contact or stifling a sneeze.

REVENGE

While Edgar depicted cotton men lingering inside closed offices, he didn't capture many of these same people in private meetings plotting revenge. Several of the men Edgar painted, including Uncle Michel, Will, Achille and René, were taking part in secret meetings of a whites-only organization that sought control of Louisiana business and politics.[116] Uncle Michel and Will, who was treasurer of the White League, were die-hard leaders[117] in various terrorist disturbances and coup attempts that began while Edgar

was still in town. Were they stacking up weapons and planning a violent overthrow in the house where Edgar lived and painted?

More desperate, they poured their embitterment into violence and revenge. Angry outbursts abounded, even with the slightest triggers. Some were plotting to throw down the local government. With an acute sense of their own slipping status, these men were willing to resort to brutality to reclaim power.

Once a supporter of the unification movement prioritizing integration in New Orleans businesses, Uncle Michel now resorted to a discriminatory standpoint. Increasingly racist, hostile and demented, he blamed the people of color in the legislature, in the countryside and in the shops and pointed to the cotton collapse as a nasty result of federal occupation.

Uncle Michel's colleague Fred Ogden was leading extremist forays to protect the election results of 1872. Terrorists were planning a battle on the Cabildo[118] soon. Later, in 1873, armed men tried to seize the police station on Jackson Square. Perhaps this brawl was the final straw that told Edgar: "Get out!"

Edgar might have tried to say soothing things and avoid criticizing his relatives; he was a houseguest and didn't want to cause infractions at home. He might have listened attentively to them but have been unable to completely support their plots for terrorism.[119] We wonder if Edgar felt guilty, appalled and out of place?

Artists need to feel emotionally supported and safe. True, Uncle Michel gave Edgar creative space, a haven for him to retreat to.[120] That might have worked if Uncle Michel wasn't angry and plotting the overthrow of the government. Bloodshed was on the upcoming male agenda, but it was cloaked under the mask of Carnival.

NEW ORLEANS CARNIVAL

Celebration never halts in the Big Easy. Carnival then and now is the busiest week of the social season, with a round of masquerade balls and parades culminating in Mardi Gras. Edgar decided to stay in New Orleans for Mardi Gras because—why not?

The men in his family were bent on making sure the Carnival coup would go as planned, a secret plot afoot. Was Edgar just an onlooker, or was he complicit?

On February 25, 1873, at the Varieties Theatre, Edgar watched the pageant ball presented by the all-male Mystick Krewe of Comus, the city's first parading organization, which included René, Uncle Michel, Will and Leonce Olivier (America's husband). But it might have been tension-provoking for Edgar, as membership in their Carnival society overlapped with that of the terrorist-driven White League.[121] One organized celebration, while the other plotted vengeance. They overlapped personnel, locales and methods. And fighting in the Civil War had taught some of these southern men how to work together as a team to acquire secret armed shipments from New York. Men became mean because they felt caged and hopeless.

Cotton merchants masked like "Darwin's Missing Links" lampooned the Republican regime.[122] Krewe members marched in the streets in papier-mâché insect costumes with huge animal heads. Often different members of a Carnival krewe are assigned a float to lead or ride beside the float on horses to protect it. René's float was flagrantly offensive. Spectators saw that the krewe was attacking the federal administration, as each of Darwin's miserable missing links was a Republican official. The krewe hoped to incite a mob of angry men to attack the metropolitan police.

René and the members of his float dressed lavishly in intricate costumes that he and Edgar had brought over from the Paris Opéra. Edgar was showing alignment with these sentiments, whether he realized it or not.

The event's bold political commentary showed the group's denouncement of a racially integrated government. This event was one of the first times a Darwin analogy was coopted by white supremacists. One illustrator painted the face of often-resented Union major general Benjamin Butler on the face of a hyena, while another showed General Ulysses S. Grant as a bug.

Edgar might not have known the insurrection was just a warmup for a bigger sinister attack on the metropolitan police in September 1874, the Battle at Liberty Place, where 8,400 White Leaguers attacked.

Did Edgar feel compassion for people of color in New Orleans, his great-uncle having married a free woman of color?[123] Did he have contact with his cousins in Paris and New Orleans who were people of color?

Staged violence broke out on the parade route. And Edgar plotted his quick exit.[124]

Chapter 8

RAVAGED HEART

Hazy Happenings at Home

News arrived blurry and bleeding from Paris. From what Edgar could decipher, his father was in jeopardy, on the verge of financial ruin. Warnings for the bankruptcy had abounded, like sea monsters rearing their heads. The first could have been in 1864, when Auguste sold Edgar's house in New Orleans for Confederate bonds,[125] now worthless. The next might have been when the De Gas Brothers business sank into debt to the family bank in Paris. And the third sign occurred when Uncle Michel's cotton business collapsed.

But the straw that broke the camel's back was René's large secret debt from speculating cotton in 1866, a loan he'd taken out with family money that had never been paid back.[126] Like a boil, it had exploded, destabilizing the family bank and disgracing his father, with creditors demanding Auguste be incarcerated.

Part of Edgar probably didn't want to leave New Orleans, but how could he ignore his stricken father? But then, how could he bear the horror of leaving Estelle and her sisters unprotected?

Perhaps Edgar couldn't be there any longer because the pain would swallow him up. He'd spoken practically no English on arrival; at least now, he was better at understanding words of woe. One improvement.

Edgar probably wanted to scream, but he had learned to restrain himself, to live in the moment as a painter, one brushstroke at a time. To survive, he had to say goodbye to Louisiana and the light-filled landscapes he would never paint and the close family he couldn't keep. He retreated inside himself.

In 1872, Edgar had left the metropolis of Paris for the genteel shabbiness of New Orleans, where everything, including patience, was worn out. Now, in 1873, he couldn't remain there, among die-hards who were drowning in their defiance and rage.

If Edgar stayed, might he have become more like René: numb to others' feelings, not really working, betraying those he loved? His brother's self-absorption now pitted him against their distraught father in Paris and innocent parade revelers in New Orleans.[127]

In 1873, Edgar must have noticed that conditions were degrading in New Orleans. Slashings, murders and muggings were on the rise.[128] More tuberculosis, plague, scabies, smallpox and cholera poured from ships into a collapsing city. Roads were crumbling. Businesses were boarded shut. Death carts were clanging for corpses. The Crescent City that Edgar had hoped to paint was self-destructing.

Edgar's Departure

We don't know when Edgar departed in March 1873,[129] but we do know it was shortly after Carnival, and his brother Achille accompanied him.[130]

Men go out to sea to release their past and cast away their regrets. There are seasons of mourning, but Edgar hadn't been raised to cry. We wonder if he grieved quietly inside. Perhaps he lamented his mother's country he'd lost, the family he didn't get, the muse swept from his side.

Returning to Paris was a journey of letting go, whether he said it or not, whether he saw it or not, whether he admitted it or not. At least he wasn't going to feel a bullet through his head or a sword through his side or hang from Suicide Oak in City Park. The ocean, a place of memories and mourning, was finally delivering Edgar home.

Death and Betrayal in New Orleans

Maybe Edgar was right to follow his instinct and leave Louisiana. Death stalked his New Orleans family.[131]

As Edgar had been warned, disease took the children, and childbirth took Mathilde. Grief-stricken and crazed, Uncle Michel begged Edgar to send him the portrait of her because it was all he had left. Edgar refused. He didn't want to lose her either.

Death was not picky. In the years following Edgar's departure,[132] five nieces and nephews died. The deceased were bathed, dressed and laid out in the parlor on the first floor of their home.[133] Loved ones were waked, women wailing into their handkerchiefs, men pressing their fists into their pockets, boys crying as they balanced the casket on their shoulders.

Then treachery ruled in 1878. René, thirty-three, abandoned his thirty-five-year-old wife[134] and five children, eloping with his mistress, America Durrive Olivier, now twenty-three. Hadn't Edgar foreshadowed this betrayal in his paintings *Children on a Doorstep* and *The Song Rehearsal?*

When he heard, Edgar probably felt angry and powerless. For him, it was an assault on the family values of duty and honor. Didn't René feel responsible for his blind wife and children? He left behind Jo (age sixteen), Pierre (age eight), Odile (age seven), Jeanne (age five) and Gaston (age three).

Even more alarming was that René and America had fled with her children, ages eight and six. We wonder: might America's children also have been his and not her husband's? René had moved next door to the young teen bride, America,[135] one year before her first child was born. When exactly did their affair ignite?

Edgar might also have thought, how ever did René get off the family grounds without disturbing the family militants, Uncle Michel (age sixty-five), Will (age forty-one) and Leonce[136] (age thirty-six), who had led the Battle of Liberty Place? They would have shot him dead.

But America and René, a callous couple, had strategized their quick escape. Was theirs a night flight while the blue-eyed Catahoula hound jumped, howled and blocked them at the courtyard gate?

The callous couple's escape was ripe with hurtles. Since Louisiana law prohibited marriage between adulterers (it was a Catholic city, after all), America and René had to flee. They couldn't have packed much for fear of suspicion. We wonder if, with René's quick exit, everything had been in place. Socks on the dresser, cravat by the bed, jacket on a chair, papers in the drawer. No note, no explanation, no one to stop him.

René and America were on the run. They had to get as far away as possible from New Orleans and fled all the way to Cleveland, Ohio. Their days were numbered if either of them came back. So they craftily obtained fake divorce papers and married bigamously on May 3, 1878, swearing that they had no living spouses. They later moved to New York. Cousin Didi had dubbed René *l'enfant terrible*, and he certainly lived up to the name.

When the Mussons realized René's abandonment, they felt a rupture so huge that they burned what René left behind.[137] Was it Uncle Michel who

1015 Esplanade Avenue (Estelle Musson's home), 2022. *Photograph by Cheryl Gerber.*

walked into René's room and noticed the fireplace was lit and chose to set ablaze René's belongings? Just a small retribution for emotional murder. Every relic of René's scorched, turned to dust—lit up in flames, the hearth transformed into a reckoning of deceit.

And when it was done, the Mussons mourned the breech between France and Louisiana. The betrayal burned because their family had loved René so deeply. The first cousin they had welcomed into their home, had eaten with, drank with, played music with, laughed and cried with, mourned with, suffered with. This nephew whom Michel had groomed like his own son. This husband whom Estelle had cared for, spoiled and birthed five children for. This father whose one-year-old son, they had buried together, sobbing, just one year before.[138]

So much shame was attached to the De Gas name that Michel legally gave Estelle and her children his surname, Musson, and barred the use of the name De Gas in the household. Michel also adopted Estelle's children, as he feared a blind single woman might lose custody. Later, they moved into a rental home farther away from the French Quarter. After he died, Estelle moved into a house on Esplanade that was built for her by her cousin James Freret.[139]

After the abandonment, even more pain mushroomed when a red rash began on Edgar's five-year-old godchild. The rash spread on Jeanne's face and neck, then to her chest, trunk, arms and legs. She died from scarlet fever on October 4, 1878. The family grieved, their home turning into a tomb of sorrow. But would René return?

No. He remained in New York and married America legally on February 6, 1879. Their first baby, Maurice, was born later that winter.[140] The couple insulated themselves while Edgar took on the burden of the family debts in France.

René made little attempt to see his New Orleans children or pay child support. So disgraced was Edgar that he didn't forgive René until 1887, after about a decade of silence. But their deeper brotherly bond was no doubt forever breached.

Meanwhile, in France

Who would face the downfall of their humiliated father in Paris? René refused to address the financial catastrophe he had caused.[141] Achille, seven years older than René, wasn't much more mature. Dabbling with the desperate and making dissolute choices had scarred him.[142]

Nonparticipation seemed to have been Achille's most generous offer. He agreed to return to Paris and served as the family messenger, but not much more.[143] He could only be counted on to embarrass the family.[144] Later, he would shoot his mistress's husband, bury their child, marry a widowed New Orleans relative[145] and flee to New York and Switzerland. He suffered strokes, leaving him paralyzed, and then died in 1893 at fifty-five.

Edgar's calls to his brothers were ignored, refused, denied. The trio of boys was broken.

EDGAR ANSWERS THE CALL

While deaths and betrayals besieged his family in New Orleans, Edgar climbed his father out of debt in France and restored honor to the De Gas name. He wanted to be a man of character who did the right thing. People had come to expect decency from Edgar, as the eldest son. Character was knowing people needed help and doing something about it.

Auguste had truly been the only family that Edgar could count on. He had forgiven Edgar when he dropped out of law school and then art school to pursue his self-education.

Edgar refused to abandon his humiliated sixty-six-year-old father in his time of need. In December 1873, when Auguste became gravely ill, Edgar cared for him in the country and took a break from painting. Edgar wrote to his first major collector, Jean-Baptiste Faure, "My father was on his way to Naples, when he fell ill here, he left us without any news of him, and when we finally discovered him, I was the one who had to leave right away, to come take care of him, and find myself confined for some time, away from my painting and my life, in the middle of the Piedmont region."

A few months later, on February 23, 1874, Auguste died utterly bankrupt. Even when Auguste's movable effects were inventoried, they were worth less than 5,000 francs, to be divided evenly among his five children.

Auguste's death hurled the De Gas family and its bank into financial disorder. Edgar steeled himself to face his father's creditors, reviewing financial papers painful to discern and impossible to pay. He was declaring that although he was alone, he wasn't dead yet. He would right the family's wrongs.

Edgar bravely arranged, with no apparent publicity, the liquidation of the family's bank and the assumption of debt to the Bank of Antwerp of 40,000 francs. He partnered with his sister Marguerite's husband, Henri

Fèvre, to pay installments for René's debts, so as not to further defame the family name.

René and Achille never pretended to help. Only Edgar, Marguerite and Henri sacrificed. On the strictest regimen, they deprived themselves to save family integrity. Henri wrote to Uncle Michel, "The 7 Fevre children are clothed in rags. They eat only what is necessary. Honor is involved."

Edgar couldn't stand indolence, in himself or anyone else. All that mattered to him was that an artist should keep working.[146]

He was forced to earn money by selling his artworks. He mentioned the "troubles of all kinds with which I am burdened." He complained about the necessity to "earn my rotten life." Even when he did sell *The Cotton Office* painting, it was for a modest sum of 2,000 francs, a humble part of paying off the debt. Even so, he expressed deep appreciation to the mayor of Pau and the curator of the museum.

ARTISTIC GENIUS

In France, Edgar would work to sell as many artworks as he could. He would keep drawing with pastels and painting until his fingers fell off. Deliverance from debt fueled his artistic vision.

Edgar gained strength from returning to his artist friends to whom he had been writing.[147] He worked industriously toward the first exhibition of a group of independent artists soon known as the Impressionists in 1874. He arranged the hangings, the effects of light and the workings of the exhibition.[148] In a few years, the group skyrocketed to international fame.[149]

Perhaps Edgar told himself that God had an "after New Orleans" for him, that he had not yet created his best paintings. Although René was lost, Edgar would live up to the dream that his baby brother once had for him: he would create paintings that would arrest the world. René once said, "He [Edgar] works furiously and thinks only of his painting....On my part, I believe, and am even convinced, that he is a genius."

Edgar had toughened in New Orleans and would grow bolder in Paris, for he'd found a raw reality for his paintings,[150] a new direction on canvas. And he would struggle to feel it deeper and deeper in explosions of color.[151]

Despite all these crashing emotional blows, Edgar kept painting, releasing his anguish into creativity. He let go of the past and strained into new creations, realizing time was predatory and finite. Did facing these personal

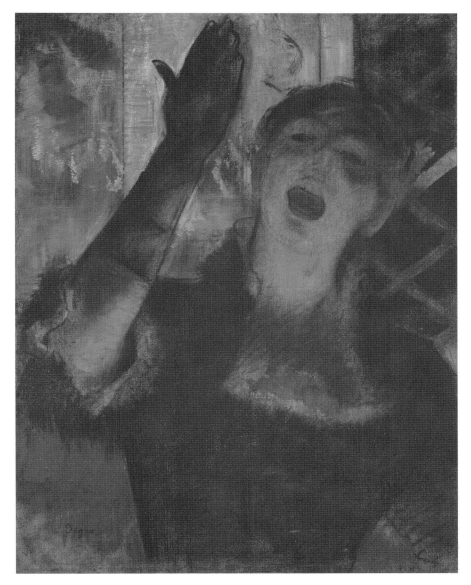

Café Singer, by Edgar Degas, 1879. *The Art Institute of Chicago, bequest of Clara Margaret Lynch in memory of John A. Lynch, 1955.738.*

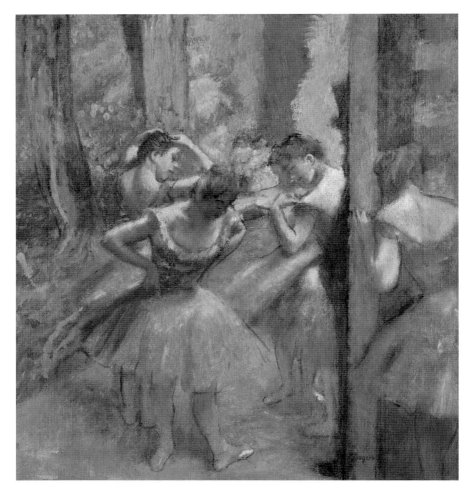

Dancers, Pink and Green, by Edgar Degas, 1890. *The Metropolitan Museum of Art, H.O. Havemeyer Collection, bequest of Mrs. H.O. Havemeyer, 1929. 29.100.42.*

disasters give Edgar more courage to face adversity as a painter, make his name, claim the laurels due? We say, "YES."

He kept painting, mostly indoors and in theaters, experimenting with off-center compositions of dancers, bathers, nudes and café figures. His mastery grew in the depiction of movement, of isolation, of complex faces, of things beautiful and sensual. His eyes continued to fail, but nothing would deter him. He created art prodigiously for forty-four years, working on sculptures after he went blind.

Edgar never married but lived alone, a belief, perhaps learned in New Orleans, that a painter could have no personal life. He remained in Paris, never returning to New Orleans, the birthplace of his mother, but always defending it. He said, "Louisiana must be respected by all her children, and I am almost one of them."

DEGAS' DIRE DEATH

Great stretches of time passed, but New Orleans wouldn't fade in Edgar's memory. He would guard portraits of his relatives in his studio, keeping them close by if he needed a reminder.[152] Perhaps they served as a substitute for the presence of the loved ones.[153] That wasn't just because they were of his family. He considered the portrait to be based on a private relationship between the artist and the sitter that should be respected. For him, these family portraits were a special experience, which he was reluctant to share.

After Edgar's death in 1917, his estate was divided equally between his sister Marguerite and his brother René. René survived Edgar, inheriting his wealth for only four years, but he kept his own secrets tight. It wasn't until René died that his French children learned of their half siblings in New Orleans. All the while, Estelle[154] had quietly made sure her children knew their lineage. Odile and Gaston De Gas Musson contacted the French court and contested their father's will[155] and won half of the estate.[156]

DEGAS' LEGACY

Louisiana is a part of Degas' legacy. While other friends had ties to the New World, Degas was the only French Impressionist to set foot in the United States and create work inside the difficult circumstances here.

After New Orleans, Edgar worked his way into becoming one of the greatest draftsmen of the nineteenth century and best artists of all time. There was an involuntary glory in his genius. He painted the paintings only he could paint. His artworks maintained a complexity that only he would fully understand. Degas became heralded in his lifetime…for beauty…for France…for New Orleans.

He shared, "Just put on my tombstone: He loved to paint."

Chapter 9

AU REVOIR

So now, dear readers,

We must leave you. Regretfully, we say goodbye to all who love family, love art, love New Orleans, love Degas.

We are trying to leave you without it hurting. Because as artists, we have found it marvelous to pen something about New Orleans and our hero, Edgar Degas, that we know someone will read.

So many stories by New Orleanians have been lost. Hurricanes, deaths, relocations have tossed away notebooks, albums, letters, poems, drawings and photographs, thrown out unwittingly, like Edgar's sketches from the family attic in New Orleans.

We suppose you, like Edgar, are enchanted by New Orleans, its winding streets, colorful Creole cottages, dreamy balconies and carriage rides, sultry verandas and fountains. And, oh, the fresh oysters, the crawfish and the trout amandine. Even the gumbo, red beans and chicory coffee—all excuses to loll at the table. Here, distraction lingers around every corner, but also laughter. Laughing at sudden thunderstorms that make you pull off your shoes and trudge through muddy streets in the rain.

We suppose New Orleans soothed Edgar, like the big mama oak trees shaded him when he walked beneath them down Esplanade, smelled the honeysuckle on the wrought-iron fences, touched the magnolias drooping down, scooped up fallen camellias fluttering on the cracked pavement.

It's hard for anyone to leave New Orleans. We imagine it must have been hard for Edgar to leave his brother, uncle, cousins, nieces, nephews—all that

Carriage Ride, New Orleans, 2022. *Photograph by Rachelle O'Brien.*

wide big family of support he had. Because despite all the pain, there was so much to love in New Orleans.

Edgar couldn't overcome the gravitational pull of where he came from. It was tough for him to go back to Paris to rescue his humiliated father, to work so fiercely to save him from prison and assume his debts after he died to save the family's honor.

New Orleans couldn't handcuff Edgar and make him stay—guilt him, blame him, shame him, frighten him with its suicide oaks and dueling trees. Edgar needed to be a great human and a great artist.

Back in Paris, he would have to play catch-up with his dream, run after it. Paint it. Show it. Sell it. And he did that, teaching us that life isn't about finding yourself. Life is about creating yourself.

Edgar Degas pursued things he loved doing and then did them so well that still today people can't take their eyes off his paintings.

"Edgar," as we say in New Orleans, "you did your mama proud." For that, we Louisiana girls thank you.

Chapter 10

REMEMBER ME

A Timeline of Degas in New Orleans

1862
Estelle Musson marries Joseph Davis Balfour, nephew to president of the Confederacy Jefferson Davis. Joe dies in the Civil War. In shock, Estelle gives birth to their daughter, Jo.

1863
Didi Musson, twenty-five; Estelle, nineteen; their mother; and Estelle's baby go to France to escape Union-occupied New Orleans during the Civil War.

1866
René De Gas returns with Estelle and her family to New Orleans.

1868
Estelle contracts ophthalmalgia, losing vision in her left eye.

1869
René marries Estelle in New Orleans.

1870
Pierre De Gas, child of René and Estelle, is born.

1871, August
Odile Musson, Estelle's mother, dies of Bright's disease.

1871
Odile, daughter of René and Estelle, is born.

1872, October
Edgar Degas arrives in New Orleans.

1872, December
Jeanne, daughter of René and Estelle, is born.

1873, February
Edgar Degas is present for Jeanne's baptism and is named her godfather.

1873, March
Edgar returns to Paris. He creates hundreds of pastels, choosing this art form because it is the quickest and he is desperate to save his father from jail, which he does.

1873
The De Gas family bank in Paris and Naples is liquidated.

1874, February
Edgar's father, Auguste De Gas, dies.

1874
Edgar exhibits in the first Impressionist Exhibition in Paris.

1875
Edgar Achilles Gaston, son of René and Estelle, is born.

1876
René Henri, son of René and Estelle, is born.

1877
René Henri dies.

1878, April
René abandons his children and wife and elopes with America Durrive, his mistress and New Orleans neighbor. They obtain false divorce papers in Chicago, Illinois, and marry bigamously in Cleveland, Ohio.

1878, September
Mathilde Musson Bell dies in childbirth at the age of thirty-seven, as does her baby, Jean Marie Bell.

1878, October
Jeanne, René and Estelle's child, dies of yellow fever.

1879, February
René and America move to New York City and legally marry on February 6, 1879. The next year, they move to Paris. Eventually, they have three children (in addition to the two children by her first marriage).

1879
Estelle gets a divorce via her father's efforts and remains in New Orleans.

1879
Maurice, the first of René and America's three French children, is born.

1881
René and Estelle's son Pierre De Gas, eleven, dies of scarlet fever.

1881
Jo, age nineteen, dies of scarlet fever at the Convent of the Visitation in Mobile, Alabama.

1882
Cousins Norbert and Emily Rillieux find success in Paris, where Norbert continues to invent.

1883
Michel Musson, Estelle's father, legally adopts Estelle and René's children, Odile and Gaston. They change their last names to Musson.

1884
William Bell, Mathilde's husband, dies.

1885
Michel Musson suffers a breakdown and dies.

1889

René and Edgar reconcile in Paris, after a decade of silence.

1894

Norbert Rillieux dies.

1902

Didi Musson dies.

1909

Estelle De Gas dies.

1917

Edgar dies. His New Orleans paintings are around his bed. Half of his estate goes to René, who oversees the sale of works in Edgar's studio.

1921

René dies. Estelle and René's children, when contacting the French court regarding their father's estate, learn of their half siblings. René's French children—Maurice, Edmond and Odette De Gas—learn of their American half brother, Edgar Achilles Gaston, and their half sister, Odile (named after her grandmother). The French court rules the Degas estate to be split equally between Edgar Degas' French and Louisiana nieces and nephews.

1961

A descendant of William and Mathilde Bell, Judge John Minor Wisdom, begins dismantling segregation through his judicial opinions in the Fifth Circuit Court of Appeals. He is now regarded as a civil rights hero.

1999

Thirty New Orleans descendants of Edgar Degas meet for the first time in New Orleans, when the twenty-four paintings Degas created there are exhibited at the New Orleans Museum of Art.

WE JUST CAN'T LET YOU GO, EDGAR!

Our book is not a biography of Degas. Plenty of brilliant art historians have written those. Rather, this book is about how we, daughters of New Orleans, think Degas' experience in our hometown deeply affected him and his artwork.

Included in the backmatter of the book are interviews with scholars, experts and curators, as well as relatives of Degas that informed our research. Additionally, we've included historical letters of the Musson and Degas families, with a narrative for further explanation.

Our thesis is that Edgar Degas' time in New Orleans was pivotal for this Impressionist artist. While in Louisiana, he managed to draw, sketch and paint family portraits and paint *A Cotton Office* and the related sketches and produce three genre paintings: *Children on a Doorstep*, *The Pedicure* and *The Song Rehearsal*.

EXPERTS REFLECT
ON THE DEGAS MYSTERIES

Dr. Gail Feigenbaum

Curator, NOMA 1999 Degas Exhibit

Dr. Gail Feigenbaum is a renowned art history scholar and world-class art museum curator. An Italian Renaissance art specialist, she has written and edited books, including *Display of Art in the Roman Palace, 1550–1750* and *Sacred Possessions: Collecting Italian Religious Art*. She has served on the faculty at Princeton University, Georgetown University, Tulane University and the University of New Orleans.[157] Dr. Feigenbaum has also served as curator at the National Gallery of Art and the New Orleans Museum of Art and worked as the associate director of the Getty Research Institute.

In 1999, Dr. Feigenbaum was the chief curator for the breathtaking exhibition *Degas in New Orleans: A French Impressionist in America* at the New Orleans Museum of Art and authored the exhibit catalogue. We spoke with Dr. Feigenbaum about Degas, New Orleans and the legacy of the exhibition.

How did you come about selecting *Degas in New Orleans* as an exhibition?
Before the exhibition, I knew the incredible painting of *The Cotton Office*. Perhaps it had even crossed my mind that Degas had some occasion to have seen something like that with his own eyes. But I had no idea that he had family here and spent a significant amount of time here with his family and that he had a kind of attachment to that family that was very particular.

I thought it was just absolutely fascinating that this quintessential Parisian would come to New Orleans and have this response: "*I have no idea what to paint here. I don't understand it here, but everything is so amazing.*" It was like the way that you might feel if you found yourself somehow in the rainforest of the Amazon: "*I have no grip on what I'm seeing. It's culturally so, so different.*"

So what Degas did was respond to family, which was familiar to him, portraying his own family. Their issues became his subjects.

It was just astonishing to me that one of the greatest French Impressionist artists, one of the greatest French artists of all time, would have gone to Louisiana. It was hard to picture this event, this episode in the history of the world, and then to be able to localize it: to walk up and see the actual house, stand in the rooms where he lived and painted and look out the window and see pretty much what he would have seen. To be able to have anchorage in this place.

Edgar's experience was an encounter. I use the word "encounter" because it's not 100 percent friendly as a word. It captures the fact that it was a strange place for him and a strange cultural experience for him.

How did the exhibition come together?

It was really the oddest coincidence and a convergence of happy opportunities. I had just come to the New Orleans Museum of Art from the National Gallery. We received a call from the lieutenant governor's office in Baton Rouge for a touristic initiative, and they were interested in the museum creating an exhibition with a French theme.

I thought the museum could do an exhibit on French Impressionism. I was just getting to know the collection, and I was very taken by Degas' portrait of his cousin Estelle. I had been reading up on Degas' stay in New Orleans. I thought: Why not that as a theme?

Though I hadn't known it, it turned out that in the late 1960s, Jim Byrnes, who had been the director at that time, had done a wonderful little exhibition on the topic.

When I offered this exhibition, I suggested we go all out and get the international loans. The museum's leadership, especially the director, John Bullard, and Sharon Litwin, went above and beyond in their support of what was probably a more ambitious project than I had first understood.

Everyone loved the idea. It was a convergence of the relevance of the topic, the topicality of it, the fact that this happened here on the streets, places that you could see. The building still stands where *The Cotton Office* was

painted. The original house still exists where Degas lived; the streets are still there. You're looking at some of the same trees. It's just so…it makes such a great space to work.

How were you able to procure all of Degas' New Orleans paintings for the exhibition?

I trained with the best people in Washington and had a lot of experience with exhibitions there. I had remembered from the National Gallery something that my favorite curator had told me was museums don't lend to museums, but people lend to people.

So I went to France and connected with Pierre Rosenberg, the former director of the Louvre, who was probably the best-known art historian in France and the most influential. I am pretty sure he helped me behind the scenes.

Paris, it's the center of the world. But I have to say that French people do have a soft spot for New Orleans. I was really able to, you know, negotiate successfully for all. I got literally everything I asked for, except one painting that was already out on loan to another venue.

The Cotton Office was a really tough loan because the director sent me a letter saying the painting was in fragile condition and couldn't travel. But you can only go and make your case in person and see what happens. We needed *The Cotton Office* because it was really the crux of the whole exhibition. It's sort of the center of the star of that story.

I went to Pau. I looked at the painting, and I thought, *This doesn't look fragile to me. It looks like it's in great shape.* The first thing I said to the director was that I was relieved because I would never ask for a painting in fragile condition. The director showed me a list of ten paintings that were considered national treasures that could not be lent outside of the French museum system. And I said, "But this is just a piece of paper. We can still talk." We talked, and I told him the story. And it was clear I'd done my homework. I knew everything about the story and even some new things about the painting he didn't know. I was serious. We were going to write a serious scholarly catalogue, and it was really going to be the occasion that was important for this painting to appear in the original in that exhibition. And, somehow by the end of the hour, he'd gotten to a yes.

I've never been so persuasive in my life.

Almost all the paintings in the exhibition were, in fact, at least begun in New Orleans. There were a few drawings that were done while crossing the Atlantic, in his notebook, and a few that were done afterwards that

might reflect things that had happened or people that he'd met when he was in New Orleans.

Why is *The Cotton Office* painting important?

There's nothing like it. It's like Picasso's *Guernica*. It is the statement of Degas in New Orleans. Because there's the convergence of the family and the place in a way that is so absolute because it is a portrait of his uncle's business.

Doing research on the painting, we found out that, in fact, his uncle had actually just gone bankrupt before that painting had happened. This was incredible to me because it changes the whole kind of charge of the picture. It's there, and it's not there. You know, once you know it, you can never forget it. But the painting works great, even if you don't know a thing. It just works differently.

Another thing about the painting itself that was so extraordinary to me, that just blew my mind, was that he first painted it with his uncle wearing a bowler-type hat with a round crown. You can see it with your own eyes when you look at the painting. You can still see the pentimento of the first-round crown. Then he painted the top hat silhouette over it. Oh my, what a difference it makes. I mean, that totally made the painting.

What did you learn about Degas' style in his New Orleans artworks?

On some level, Degas' psychology is so acute. He is such a student of the human condition, but he never explains anything. He paints it. You can see it, and if you're a theater person, you know the difference between saying the lines and acting. It's not something that you say or you explain. It's something you perform. For Degas, it was something he paints; he captures it and conveys it.

It was like he was groping in these paintings. There's a kind of unfinished search in these works. You could still feel it. There was a kind of tentativeness, where he was working stuff out. So the art itself was very interesting, maybe more so than what you get when somebody has worked out their style and they keep doing it.

Did anything stand out for you when you were researching Degas for the exhibition?

I think of the Musson-Degas family letters and reading and crying in the car because the stories were so affecting. There was just such undiluted pain in them. So it was really emotional. I think all that creates some kind of environment for the paintings. It's unusual.

Were Edgar and Estelle particularly close? Was she the cousin that he painted the most?

I think he did. There was a kind of special relationship with Estelle. People have sort of speculated that it was her problems with her vision that made him especially feel tenderly toward her. But you know, it's impossible to say what creates sympathy. I think she was a very vulnerable, gentle soul, and in the end, she was a survivor.

Do you think Degas' artwork changed after his time in New Orleans?

Degas' time in New Orleans was a difficult one. He was a French artist, totally out of place. It seems he was spinning his wheels, trying to figure things out, which led him to create very interesting artwork, many of which were unfinished. The fact that they're not super polished in a way makes them just sort of more interesting to approach. Degas was groping in his artwork, searching, and we can see that process of working it out through these New Orleans artworks. It's art about art. He did have a profound experience, so it may be difficult to say how it impacted him.

It's such a legacy you're leaving. As you look back on that twenty years later, what do you think was the biggest contribution of this exhibition? What are you remembering as the things that really made a difference?

It was how personally that people in New Orleans took it and the kind of personal gratitude they had for our having brought this amazing exhibition, this amazing story to New Orleans. People would stop me at the grocery store and thank me. I've worked on a lot of exhibitions at the National Gallery or the Getty, and people are just used to having Vermeer one month and Cézanne another. They have this really rich diet of exhibitions that come all the time.

But when you have something that's really tailored to your circumstances and that is a New Orleans story, it's very personal. And you don't have this steady diet of the circuit of the big international monographic exhibitions that come to Los Angeles or New York or Washington. It's a really different experience. And it's, it's much more personal. In New Orleans, people were touched by it, they were moved by it. I think that they also felt the beauty of it.

Well, your exhibition propelled us into studying Degas in New Orleans. I wrote a play, which was done at the museum. Then Rory and I wrote a screenplay. And now we have this book.

I am glad to hear that you have felt moved by the story because I think the story is amazing.

When I think about what this Parisian guy must have felt like when he got off the train by Lake Pontchartrain in 1872, I just think: *Whoa. This incredibly sophisticated Parisian ended up here, where he first sees alligators. He can't even sort of begin to approach them. It's really too exotic, too foreign for him. It can't be his subject.*

In looking at Degas' time in New Orleans, how do you think this story may be viewed differently now?

One topic it is important to include is family. Edgar's maternal uncle (Vincent Rillieux) had a common-law relationship with a free woman of color (Constance Vivant), and they had children. While developing the Degas exhibition, we reached out to a friend of their family, who shared that Rillieux's descendants did not want to be included. Unfortunately, the opposite message was relayed to the *New York Times.* Looking back on it now, we could have done additional outreach rather than rely on and trust this one informant.

RECOMMENDED READINGS

Boggs, Jeanne. *Degas, 1834–1917.* New York: Metropolitan Museum of Art, 1988.

Feigenbaum, Gail. *Degas in New Orleans: A French Impressionist in America.* Seattle: Marquand Books, in conjunction with the Publications Office of the New Orleans Museum of Art, 1999.

———. *Display of Art in the Roman Palace, 1550–1750.* Los Angeles: Getty Research Institute, 2014.

———. *Sacred Possessions: Collecting Italian Religious Art.* Los Angeles: Getty Research Institute, 2011

Shackelford, George. "The Dance Compositions of Edgar Degas." Yale University dissertation, 1986.

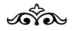

Dr. Isolde Pludermacher

Chief Curator, Musée D'Orsay

Dr. Pludermacher is a distinguished art historian and author. She authored *Edouard Manet: Les Femmes* (2015) and *Manet* (2013), and she coauthored *Faces of Impressionism: Portraits from the Musée d'Orsay* (2015). Currently, she serves the chief curator of painting at the Musée D'Orsay and is the curator who oversees Degas' artworks in the collection.

Dr. Pludermacher curated the spring 2023 exhibition *Manet/Degas* at the Musée D'Orsay, which also traveled to the Metropolitan Museum of Art. This exhibit included at least four artworks created by Degas in New Orleans.

In Paris, we interviewed Dr. Pludermacher to learn her perspective about Degas, the significance of his New Orleans artworks today and the *Manet/ Degas* exhibition.

Can you tell us about the *Manet/Degas* exhibition?
One part of the show will be about Manet, Degas and politics, with the question of the French and American Civil Wars. Manet and Degas were involved in both wars. And they were very close during the French Civil War in 1870; they were in the army together.

Degas' New Orleans artworks will be well represented. Of course, we wanted to show Degas' experience in New Orleans. We will have several paintings related to the Civil War and politics, including *The Cotton Merchants* and *The Cotton Office*. The question of cotton relates to the Civil War topic. In the same gallery, we will display a painting by Manet that features a battle where a Union ship fires on a Confederate ship. The painting was first shown in Paris in 1864 during the American Civil War, not in the Salon, but in the window of an art dealer.…Then, Manet's painting was shown again in 1872, just before Degas left for New Orleans. Degas knew the painting by Manet.

Looking at *The Cotton Merchants*, it is a very different style than *The Cotton Office*; it's been described as more spontaneous. Can you tell us more about these paintings?
Yes, you are right. They are very different in techniques and tone. There is, of course, the same table with cotton everywhere. But the suits are not the same, summer suits and hat [in *The Cotton Merchants*]. The presence of this seascape [a small painting hung on the wall in *The Cotton Merchants*] to me is very interesting because with the ships was the trade of cotton and the connection with Europe.

Musée D'Orsay, 2022. *Photograph by Rory O'Neill Schmitt.*

Do you think his time in New Orleans was significant for Degas?

Yes, I think it was very important for Degas, as it was related to his mother, of course, that he didn't have a chance to know very well. He didn't speak a lot about her. But according to his niece, he was very connected with his mother. In his letters, he writes about "his" country, he says; it's a little his country, too.

In New Orleans, there's not only his mother's family but also his two brothers. They are Parisians, but Degas sees them becoming Creoles,

American. I think the way that he represents Achille here [in *The Cotton Office*] is very interesting because his skin is darker than the others' skin. Of course, the question of being related to Black people, or different quadroons with all of the degrees he described, is very close to what described Creole society at that time. He writes a lot about this in his letters. So I think it might have given him anxiety because he talked about this a lot. He says, *Wow, it's wonderful, but I can't paint it.* He talks about white babies in Black arms. He seems to be kind of experiencing something new maybe about the origins of his family, the possibility of being mixed. Of course, he was not used to this in France before.

New Orleans was a very strong experience for him. He is a man of family and has always been....To me, it is very important his being connected with his family and his own history, with his mother he lost when he was young. It was also to, of course, to discover something totally new—landscapes, light. Light was of course difficult for him because his eyes were sick at that time, so he suffered from light; he writes a lot about this.

Also, when we look at all his paintings, there is really something about space in the houses with the windows which are very specific [to New Orleans], not like in France. I could notice that also when I was in the States during the summer, you never have windows like that here. We have *Children on the Doorstep* [in the exhibit], too.

About family, he was very proud of what he thought was a success for his brothers. He writes all the time on the letterhead of the name with the De Gas Brothers firm; he was talking about this in his letters. I think that the tone of his letters is very enthusiastic; he was happy to be there. He was proud....

He was really thinking about his art as if he himself was a dealer. He writes it could be bought by a British cotton buyer. Becoming like his brother, working for the market, which is very not Degas.

What do you like about Degas' artwork in general?
I like his works because they are always very intellectual. There's always a story that you don't fully understand in his paintings...attention to some details and a very specific way of feeling and describing space. That will be very interesting in the *Manet/Degas* exhibition, because Manet is totally different, especially with placing his figures in the middle [of the canvas]. But Degas' figures are always not in the middle, not facing the viewer. He was always, always, always working, trying to find something better and new. He doesn't care about what people are thinking or about journalists; he didn't like them. But he's very—hard with himself. It's hard for him to finish works.

This one [*The Cotton Office*] is very much finished. He always works a lot with the same topic but not in the same way. That's very relevant in New Orleans because he writes, *I can't paint New Orleans, new subjects with all these landscapes, etc., it's very interesting but I want to do one thing. I'm a Parisian, and I want to do one thing well.* To do it well, you can't do everything; you must focus on something. So he's always focusing on the same things....

He's difficult too; he was a hard man. His political views were very controversial, especially at the end of his life. And he didn't want to be liked by others. He didn't care about this. But he was a very faithful friend also. He was very sensitive to many things. He's very complex and very smart, of course. He has a lot of contradictions.

I was trying to think 150 years later, why people still like his work so much. Going to the gallery, room 31, to see his New Orleans paintings—people still care about him. There's so much tenderness there. I'm wondering, we've changed so much over the generations. Why do you think people still love him?
I think it's the dancers. He was the first painter to show the opera and dancers with so many paintings and drawings. Everyone likes Opéra de Paris. I think it's a popular subject.

The way he represented dancers was so interesting. The space is not what you expect. He's not painting dancers with nice gestures but when they are tired....He was very interested in gesture in general....You really feel it in the way his uncle was touching the cotton, a specific gesture. In all of his paintings, when someone is doing something they are used to doing, you can see that.

It's specific. He's testing the quality of the cotton, like a woman tests the quality of a dress. It's beautiful.
Exactly. He doesn't look at the others [his back is turned]. We can see their experiences.

RECOMMENDED READING
Pludermacher, Isolde. *Edouard Manet: Les Femmes*. Paris: Des Falaises, 2015.
————. *Manet*. Paris: Musée D'Orsay, 2013.
Shackelford, George, Guy Cogeval, Isolde Pludermacher and Xavier Rey. *Faces of Impressionism: Portraits from the Musée d'Orsay*. Fort Worth, TX: Kimbell Art Museum, 2014.

Left: *Yellow Dancers (In the Wings)*, by Edgar Degas, 1874/1876. *The Art Institute of Chicago, gift of Mr. and Mrs. Gordon Palmer, Mrs. Bertha P. Thorne, Mr. and Mrs. Arthur M. Wood and Mrs. Rose M. Palmer. 1963.923.*

Below: *The Dancing Class*, by Edgar Degas, 1870. *The Metropolitan Museum of Art, H.O. Havemeyer Collection, bequest of Mrs. H.O. Havemeyer, 1929, 29.100.184.*

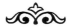

VICTORIA COOKE

Curator and Director of the Art Galleries for the University of North Georgia

Victoria Cooke is an esteemed art historian who specializes in art of the American South, as well as art of eighteenth- and nineteenth-century Europe. She has curated major exhibitions on Impressionism, American Modernism and contemporary African American art. Currently, she serves as the director of the art galleries for the University of North Georgia.

A dedicated researcher, she worked on *Degas and New Orleans: A French Impressionist in America* exhibit at the New Orleans Museum of Art in 1999 with curator Dr. Gail Feigenbaum. The exhibition was part of the Franco-Fête, a celebration of Louisiana's French roots. With museum director Jim Byrnes, she coauthored the catalogue chapter "Degas' Family in New Orleans: A Who's Who."

To discover information about Degas' family, Victoria accessed local records and completed expansive research, including reviewing baptismal records of family members, reading the Louisiana family's letters in the Tulane University archives and speaking with descendants of the family. Her dedicated research exquisitely resurrected the lives and personalities of historical figures. For instance, deaths of children were not uncommon in the nineteenth century, but grief was still gut-wrenching. When reading Michel Musson's letter mourning the death of his child, how could Victoria not weep?

Victoria spoke with us more about her research on the Musson–De Gas family in New Orleans.

What was the biggest discovery the exhibition team?

The biggest discovery of the exhibition was finding *The Sick Room* painting. The curatorial team knew that this New Orleans painting existed but had not been able to locate the artwork. During World War II, Nazis had stolen many artworks, and one hypothesis was that *The Sick Room* was one of these paintings that has never been found.

A colleague, Walter Feilchenfeldt, located *The Sick Room* and secured clear provenance to show the artwork wasn't stolen, The artwork's owners agreed to loan the painting for the *Degas and New Orleans: A French Impressionist in*

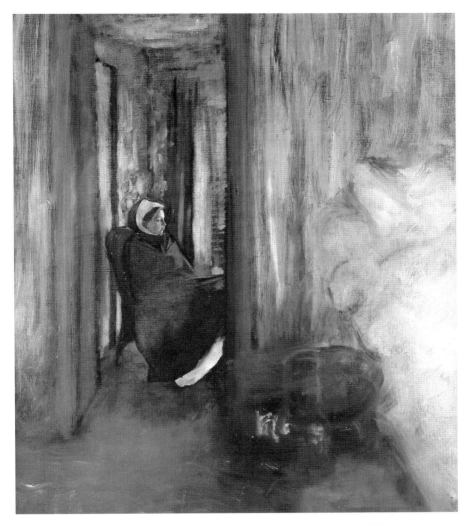

The Sick Room, by Edgar Degas, 1872–73. *Private collection, courtesy of Walter Feilchenfeldt.*

America exhibition, as long as very strict measures were in place to protect it—including safety procedures in terrorist situations.

Are there any mysteries still remaining about Degas in New Orleans?

We know that Degas created many preparatory drawings for most of his paintings. For the *Cotton Office* painting, which he finished in France, he

would have created several drawings of the cotton office in New Orleans before he left. Unfortunately, there are many drawings for this painting that are still missing. Are these drawings lingering somewhere in New Orleans? Will they ever be found?

Did New Orleans change Edgar Degas? If so, how?

This was a pivotal moment in his career, as soon after leaving New Orleans, he founded the Impressionism movement. While in New Orleans, his family pressured him to go into business, even poking fun of him as the "graaaaande artiste." Edgar witnessed Achille and René working as businessmen and likely thought, *We can make art a business.* When his family and their finances fell apart, they all depended on Edgar to put it back together.

RECOMMENDED READING

Brown, Marilyn. *Degas and the Business of Art: A Cotton Office in New Orleans.* University Park: Pennsylvania State University Press, 1994.

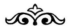

DR. BARBARA BLOEMINK

Curator and Author

Dr. Barbara Bloemink is an art historian, curator and scholar who has served as the director and chief curator of five U.S. art and design museums, including the Guggenheim Hermitage Museum, the Smithsonian National Design Museum, the Virginia Museum of Contemporary Art and the Hudson River Museum. She has also curated over seventy international exhibitions. She lived for a year in New Orleans and contributed a major essay, "Eden, Babylon, Our Venice," to the catalogue for the first *Prospect, New Orleans Biennial* after Hurricane Katrina.

We spoke with Dr. Bloemink about the potential significance of Degas' time in New Orleans and deeper meaning of artwork through close readings of the paintings he executed while he was there.

What about the New Orleans Degas story interests you?

The idea of a closer investigation than has been done of Degas' New Orleans family in relation to his artwork is very interesting. Until now, his short visit to New Orleans has been treated largely as a footnote in the history of his biography, but given your intimate long-term knowledge of the city and his close family ties, it is undoubtedly worth further investigation and will be an important addition to our understanding of his work.

This is particularly true as, while he was there, Degas was living with his brother's family and painted a number of highly intimate portraits, which are remarkable. At the same time, during his tenure with them, their cotton business went bankrupt. As you note, these experiences and the different atmosphere of New Orleans may have influenced his subsequent style and subject matter.

When Degas returned to France, he was confident, and he took a different approach to painting. What are some ways that an art historian would go about developing this hypothesis that a real shift occurred in his approach to artmaking after New Orleans?

Initially, an art historian would do several careful readings of Degas' paintings done while living in New Orleans in terms of not only subject matter, which is key, but also stylistically, compositionally and in terms of all the details and how they might relate to each other on many levels: psychologically, metaphorically or whether they might represent actual objects or specific people who can be identified through comparison with contemporary photographs or other titled works.

Other things to be explored are how Degas treated lighting, perspective, i.e., angles from which he approached his subjects, materials he predominantly used, such as oil paintings or pastels or simply graphite. Also often significant is the kind of brushstroke an artist uses: is the paint applied in a broad, thick manner with a brush or palette knife or with tiny strokes in a flat, smooth surface?

One would then do the same exploration with works he painted both before and after living in New Orleans to determine whether there appear to be significant alterations that might have been affected by the different lighting, geography, customs, etc. related to such a different location and surrounding circumstances.

Of course, these chances could also be due to an evolution and maturation of the artist's work, so it is also useful to read any correspondence, diaries, written notes of conversations to and from the artist and circumstances/

changes in his life and health that might contribute to the changes in his work while in New Orleans.

In New Orleans, Degas lived alongside his female relatives and children and painted their portraits. He seemed very inspired by them. What was he able to capture based on his location and access to subjects?

Degas' brother's home was filled with women, so in living there, Degas was able to have an unusually intimate experience with them and their everyday lives. This was particularly true of his sister-in-law [Estelle], whom he painted several times, creating beautifully private-seeming portraits of her and usually hidden views of scenes like the rehearsal for a musical recital. I think because of this, he may have become more interested in women as subject matter, as he returned to Paris and created his extraordinary series of pastel private "keyhole" views of women bathing and young ballet dancers. During and after New Orleans, his work reflected an uncommon view for a man on women's everyday lives.

When he returned to France, Degas lived alone as an unmarried man. If he wanted to continue portraits of women, where could he go?

To be able to see younger women's movement and paint indoors, he could go to brothels and the ballet. Brothels were a place where Degas could watch prostitutes bathe. He could paint indoors at the ballet, both rehearsals and performances, to paint the ballerinas. (Many of these dancers were young girls who didn't make enough money by performing, so many were also prostitutes.)

Degas painted his female relatives and painted Estelle very often. Even looking at the face of the balcony portrait of Mathilde, she resembles Estelle. Have you noticed an artist re-creating the same face before, even if the artwork titles have names of the individuals that are different?

That often happens as more research is done on an artist's work: subjects are slowly identified or reidentified as more information is uncovered. I was researching the artist Florine Stettheimer's artworks for my biography, for example. I found a few paintings in a box given by her lawyer to Columbia University that were titled "not Florine." But when I looked at them and compared them to photographs of the artist, it was evident they closely

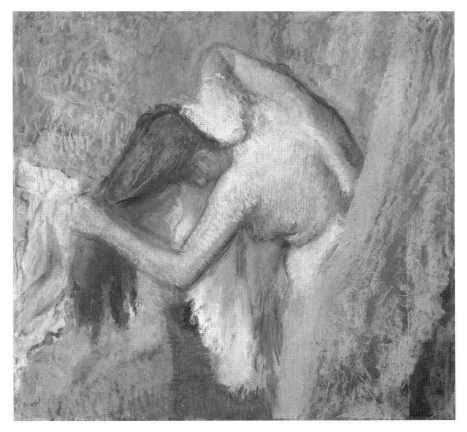

Woman at Her Toilette, by Edgar Degas, 1900/1905. *The Art Institute of Chicago, Mr. and Mrs. Martin A. Ryerson Collection, 1937.1033.*

resembled her—all her facial features matched—and none of the works given to the university were not by the artist herself. So I retitled them, and since then, they have been accepted as self-portraits by other scholars and curators.

I think with close reading of the woman on the balcony and comparison of her facial features with the titled portrait of Estelle, it does appear to be a portrait of her. It would be good to see if there are any photographs of her or any other portraits with which to compare this painting.

Estelle was able to sit for Degas and pose, as she was available. She was blind and pregnant and may not have minded sitting and being painted. We've heard that Estelle was Degas' favorite.

What type of evidence would help to support that claim?
If Degas painted Estelle the most often, they would have had the opportunity to develop a deep friendship. Painting a portrait of someone is by its very nature an intimate experience. It takes a long time and, for a good portrait, requires that the artist capture more than just the appearance of the subject but also some key aspect of her personality. We don't know whether Degas or Estelle were aware that her husband was having an affair during the time the portrait was being painted. However, he did know what she was mostly blind and pregnant and so particularly vulnerable. In his seated portrait of Estelle, Degas captured not only her inner sense of stillness but also her vulnerability and universal sense of humanity.

Was it love? There's a tenderness in her portraits. Whether or not this was anything other than familial love, there is a kind of gentleness in her face that is in the handling of the paint and based on the physical hours that it would have taken to create the portrait. That fascinates me about significant artworks.

RECOMMENDED READINGS
The most detailed survey of Degas' art and career is by Jean Sutherland Boggs:
Boggs, Jeanne. *Degas, 1834–1917.* New York: Metropolitan Museum of Art, 1988.

The two most reliable biographies of Degas are:
Loyrette, Henri. *Degas.* Paris: Fayard, 1991.
McMullen, Roy. *Degas: His Life, Times, and Work.* Boston: Houghton Mifflin Harcourt, 1984.

A book of all of Degas' letters that gives a great overview of his personality is:
Reff, Theodore. *The Letters of Edgar Degas.* New York: Wildenstein Plattner Institute, 2020.

Additional readings include:
Bailey, Colin. "A Compulsive Perfectionist." *New York Review*, April 7, 2022. www.nybooks.com/articles/2022/04/07/a-compulsive-perfectionist-edgar-degas.
Bloemink, Barbara. *Florine Stettheimer: A Biography.* Munich, Germany: Hirmer Publishers, 2022.

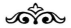

Dr. C.W. Cannon

Professor of New Orleans Studies, Loyola University, New Orleans

Dr. C.W. Cannon is an author who has written extensively about New Orleans. A Fulbright scholar, he teaches courses in New Orleans studies at Loyola University New Orleans. His pantheon of work includes New Orleans novels (*Soul Resin*, *Katrina Means Cleansing*, *French Quarter Beautification Project* and *Sleepytime Down South*), as well as anthologies (*Louisiana in Words* and *Do You Know What It Means to Miss New Orleans*). His latest book is *I Want Magic: Essays on New Orleans, the South, and Race*. He is a frequent contributor to *The Lens* (thelensnola.org).

Dr. Cannon spoke with us more about life in New Orleans in the 1870s, which we tied to Edgar Degas' family.

What was Reconstruction like in New Orleans?

New Orleans was in the Confederacy for barely over one year because the city became under Federal occupation early in the Civil War. Only a few years before Edgar arrived, Reconstruction was established with a progressive constitution in 1868 that integrated public schools and transportation and established a government that further liberalized racial laws, including the legalization of interracial marriage. Unfortunately, all of these laws were later undone by successive Jim Crow governments.

What were race relations in New Orleans like at this time?

During Reconstruction, there were many supporters of racial liberation and equality in New Orleans. Francophones of different races, radicals, scalawags (white radical southerners), as well as German, Irish and Italian immigrants, formed an anti-racist bloc in the city. Many looked to France as a model, as France banned slavery for good in 1848.

At the time, there was also antislavery media. Jean Charles Houzeau, a Belgian and a radical Republican supporter of Reconstruction, founded the pro-equality *New Orleans Tribune* newspaper. With a large German population, New Orleans had two German newspapers before the Civil War, and one of them took an antislavery stance.

American journalist and novelist George Washington Cable fought against white supremacy and advocated for racial equality. Cable lived in New Orleans until 1882, when he began receiving death threats and was forced to flee the city. Alfred Mercier, a white Creole author who wrote in French, fell prey to "lost cause" sentimentalism after the Civil War, though he continued to deplore race prejudice as a corrosive social force. He wrote *L'habitation St. Ybars* in 1881. It is regarded as perhaps the best Louisiana Francophone novel about an antebellum white Creole family. Despite his antipathy toward what he viewed as a hostile occupation during Reconstruction, the novel roundly condemns race prejudice and promotes a vision of international liberation from arbitrary social hierarchies.

The Unification movement supported a form of racial conciliation in New Orleans and had several supporters.

René De Gas and Michel Musson were early supporters of the Unification movement. Can you share more about antebellum New Orleans?

In antebellum New Orleans, free people of color did not have the same rights as free whites. Though the wording of the last article of the Code Noir of 1724 gave free people of color the same rights as white people, later laws contradicted that principle, and the Americans were particularly distrustful and repressive toward free people of color, stripping them of rights they had enjoyed under the French and Spanish.

The White League, a white supremacy group, formed in opposition to Reconstruction. After the Civil War, sadly, white supremacy became the glue that allowed white Creoles and Anglos to overcome the mutual distrust and enmity that had characterized their relations during the early American period. The White League (like the Ku Klux Klan and Knights of the White Camelia) used political terror to drive Black voters from the polls. The White League brought together resentful whites of many ethnicities, Anglo, Creole, Irish, etc.

René De Gas and Michel Musson later joined the White League, and they participated in a Comus Carnival procession in 1873, while Edgar Degas was visiting New Orleans. Can you tell us about how politics and Carnival mixed?

In the first half of the nineteenth century, many new Anglo-American arrivals disapproved of the indiscriminate mixing of races that they felt was condoned and promoted by Creole New Orleanians. Carnival was a particular locus for racial fears and resentments. In the nineteenth century, Anglo authorities made

efforts to regulate Carnival, passing laws to formalize and appropriate Mardi Gras. Public balls were banned. Only private balls were allowed, and these were segregated. In 1857, the Mistick Krewe of Comus sought to reinvent Mardi Gras. Comus balls were restricted to members who had been vetted in their elite gentlemen's club. Many were white supremacists.

Can you tell us more about social life and marriage during this time in New Orleans?
There was undoubtedly more casual social mixing of races in New Orleans than in other American cities.

Yes, a New Orleans relative of Edgar Degas had a mixed-race common-law marriage. The brother of Edgar's mother, Vincent Rillieux Jr., married Constance Vivant, a free woman of color from a prominent free people of color family in New Orleans.[158] **Can you share more with us about marriage at the time?**
Common-law relationships existed frequently between white men and free women of color, as legal marriage between the two was not allowed (until legalized briefly during Reconstruction).

Plaçage is a formalized term that has recently come into question. Many free women of color were "placed" in relationships with white men. Some young wealthy white men had relationships with young beautiful free women of color for a short time. In other relationships, some white men had two separate families, wherein they transferred property to their Black partners and had open relationships with their children. Some couples had a common-law monogamous marriage and created a household and family together. Their children often blended into Black society.

RECOMMENDED READING
Bell, Caryn Cossé. *Revolution, Romanticism, and the Afro-Creole Protest Tradition.* Baton Rouge: Louisiana State University Press, 1997.
Dudley, Tara. *Building Antebellum New Orleans: Free People of Color and Their Influence.* Austin: University of Texas Press, 2021
Fertel, Rien. *Imagining the Creole City: The Rise of Literary Culture in Nineteenth Century New Orleans.* Baton Rouge: Louisiana State University Press, 2014.
Gill, James. *Lords of Misrule: Mardi Gras and the Politics of Race in New Orleans.* Jackson: University Press of Mississippi, 1997.
Hirsch, Arnold, and Joseph Logsdon, eds. *Creole New Orleans: Race and Americanization.* Baton Rouge: Louisiana State University Press, 1992.

Houssaye, Sidonie de la. *Les Quarteronnes de la Nouvelle-Orleans: Dahlia.* Shreveport: Centenary College of Louisiana Press, 2014.

Mercier, Alfred. *Saint-Ybars.* Shreveport: Centenary College of Louisiana Press, 2015.

Nystrom, Justin. *New Orleans after the Civil War.* Baltimore, MD: Johns Hopkins University Press, 2015.

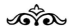

DR. BARBARA EWELL

Professor Emerita of English, Loyola University, New Orleans

Dr. Ewell is professor emerita of Loyola University New Orleans. Her books and editions include *Kate Chopin*; *The Awakening and Other Writings by Kate Chopin*; *Sweet Spots: In Between Spaces in New Orleans*; *Southern Local Color: Stories of Region, Race and Gender*; *Voices of the American South*; and *The Anthology of Spanish American Thought and Culture*.

Dr. Ewell is an accomplished author and leading scholar on Kate Chopin (1850–1904). Chopin was a groundbreaking novelist and short-story writer who lived in New Orleans when Edgar Degas visited. Since her husband's cotton office was near those of the Mussons and De Gas Brothers, and since such businessmen typically traveled in the same social circles, we talked to Dr. Ewell about Kate Chopin's experience.

Can you tell us about Kate Chopin's life in New Orleans in the 1870s?

Kate moved here as a young bride with her husband, Oscar Chopin, in 1870. They came after the war, when, in fact, things were at their worst. Despite some hopeful developments for racial reconciliation, the South in general was devastated and impoverished by the war and its aftermath.

The Chopins rented properties in the Lower Garden District and on Louisiana Avenue. In New Orleans, Kate gave birth to five of her six children and was busy raising her young children here and running the household.

According to some accounts, Chopin could be unconventional. For example, she enjoyed walking by herself through the city. Women were generally not supposed to go out unaccompanied, certainly not women

of her class, but Chopin evidently walked around New Orleans, took the streetcar, went down to the Quarter and even the business district around her husband's offices. It was one of her pleasures. She did write that she loved to walk around the city and check things out.

There were a number of literary circles in New Orleans at the time. Mollie Moore Davis hosted a popular literary salon, and both Grace King and George Washington Cable would have been in town. Kate certainly knew their work. It was a very active literary community, both male and female, but as far as I know, Kate was never directly involved in it. She began publishing her writing after leaving New Orleans.

As with other New Orleanians of her class, Chopin would go with her family to Grand Isle (a town on the Gulf of Mexico) to escape the heat and disease of the summers. That island resort was, of course, the foundation of her novel *The Awakening.* So I think she must have participated in the social life of Louisiana in some ways.

Were there any connections between Kate Chopin and Edgar Degas and their families?

Kate's husband, Oscar, was a cotton factor. He may have worked in the cotton market with Degas' family, as it was a fairly small community. I don't

Lower Garden District, 2022. *Photograph by Cheryl Gerber.*

know specifically if Edgar Degas and Kate Chopin ever met, but their families were in the same business.

Another commonality is that her husband was a member of the White League, along with René De Gas and Michel Musson. Kate herself had been a pretty strong Confederate sympathizer; one of her brothers had died in a Union prison during the war when she was eleven or twelve years old.

How did Oscar's work as a cotton factor affect Kate?

His work certainly connected her with the larger world. Oscar was in the business of factoring cotton, working with growers and then selling it abroad. That would have made him aware of the prices of cotton and the world commerce at least in that mercantile area. His work probably would have connected her with the business world and with the current economic situation.

Also, I'm sure it helped create and shape her life because Kate was not from New Orleans. She was from St. Louis, and she was probably more or less dependent on Oscar and his local connections.

His profession definitely affected her life when the cotton market collapsed in 1879. When Oscar's business failed, he had to move his family to Cloutierville, a small town south of Natchitoches, Louisiana, where the Chopin family owned a house and they could live more cheaply. In that sense, it very directly affected her life because when she moved to Cloutierville, she became particularly affected by the people there. Those people—the Acadians—are who she wrote about a few years later.

When did she become a writer?

Kate was always a writer. She wrote journals in high school and kept journals through most of her life. But she didn't begin publishing until 1889. A poem was her first publication.

In the 1880s and 1890s, there was quite a market and an interest in local color, regional writing, and especially from the South. The expansion of the nation after the Civil War had increased interest in the variety and the diversity of the country. People learned about other parts of the country through newspapers and journals.

It was a very interesting moment because it was at that point that printing presses became automated, and the railroad distribution system was developed. Women could sit at home and write their stories about local places and send them out to newspapers or journals, which were begging for filler. It created a market that many women writers benefited from.

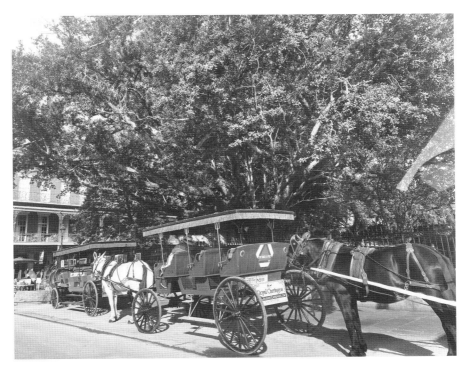

Joy Ride on a Carriage at Jackson Square, New Orleans, 2022. *Photograph by Rachelle O'Brien.*

Kate kept a very detailed account book. For every story she wrote, she would indicate the day she wrote it and how many words there were. Then, she would note where she sent it out. And she would document when it was returned, every time, until it was published. Then, she would notate how much she was paid for it. So, for 90 percent of her stories, we have a detailed accounting. She was a serious businesswoman in that sense, and she was purposeful about getting her own writing out. Her first novel was self-published, but that just indicates how much she wanted it published.

In St. Louis, she had her own literary circle and a number of newspaper contacts. She was very engaged by the literature and ideas of her time.

Did her husband support her writing?

Unfortunately, he was dead. A few years after they relocated to Natchitoches, Oscar contracted swamp fever (malaria) and passed away. Soon after, Kate

moved home to St. Louis to be near her mother. It was then that she began publishing her writings.

Oscar was evidently a very supportive husband. Some of the portraits we have of him from her short fiction are certainly positive if not exactly flattering. He did seem to enjoy his wife. She was apparently a bit of a mimic and would entertain her family with mocking other people. Oscar apparently liked that.

What's it like being a writer in New Orleans today? What is the hardest thing?

Distraction. New Orleans is a distracting place, and it's not particularly a very intellectual place. It doesn't value intellectual pursuits very much. So, if you're a serious writer, it can be a difficult place to live.

Carnival does define the spirit of the city. Carnival is essentially frivolous, about doing it all before you die, because you might die tomorrow. That's a feeling that pervades the city all the time. There's a close association with death. We know death is right here—with yellow fever, hurricanes, floods. This is a mortal city, so you may as well enjoy what time you have. This attitude is not unique to New Orleans, but it is certainly part of what defines the city—that sense of jeopardy.

RECOMMENDED READINGS

Ewell, Barbara, ed., with Pamela Menke. *Southern Local Color: Stories of Region, Race and Gender.* Athens: University of Georgia Press, 2002.

Ewell, Barbara, ed., with Suzanne Disheroon Green, Sarah Gardner, Julie Kane, Lisa Abner, Pamela Glenn Menke and Philip Dubisson Castille. *Voices of the American South.* New York: Pearson Longman Press, 2005.

Ewell, Barbara, ed., with Suzanne Disheroon, Pamela Menke and Susie Scifres. *"The Awakening" and Other Writings by Kate Chopin.* Toronto: Broadview Press, 2011.

Parham, Angel. *American Routes: Racial Palimpsests and the Transformation of Race.* Oxford, UK: Oxford University Press, 2017.

Parham, Angel, and Angel Adams Parham. Illustrated by JaJa Swinton. *The Black Intellectual Tradition: Reading Freedom in Classical Literature.* Camp Hill, PA: Classical Academic Press, 2022.

Toth, Emily. *Kate Chopin.* New York: William Morrow & Co., 1990.

———. *Unveiling Kate Chopin.* Jackson: University Press of Mississippi, 1999.

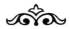

THE RILLIEUX, SOULIÉ AND DEGAS FAMILIES

The Rillieux, Soulié and Degas families are connected by shared ancestors.[159] We also researched these families, as they were Edgar Degas' relatives in Louisiana:

THE RILLIEUX FAMILY

A relative of Edgar Degas had a mixed-race common-law marriage. In the 1800s, the Rillieux name became common among the free people of color community in New Orleans.[160] Edgar Degas' great-grandfather Vincent Rillieux Sr. (?–1800), a white male, was a successful real estate developer who also owned two banks in New Orleans. His son (Edgar's great-uncle) Vincent Rillieux Jr.[161] fell in love with Constance Vivant,[162] a free woman of color from a prominent free people of color family in New Orleans. They had a faithful relationship like marriage, sometimes called a left-hand marriage.[163] Vincent loved and respected his family and acknowledged and educated his children.

One of Vincent Jr.'s children, Norbert Rillieux (1806–1894), was a contemporary of Edgar's.[164] Norbert attained a European education and became incredibly successful as a leading chemical engineer of his time whose steam inventions revolutionized the sugar industry. Brilliant, he was the most sought-after engineer in Louisiana and became internationally renowned.

Norbert Rillieux lived and worked in New Orleans for a time, owning a house in the French Quarter on Royal Street—not too far from the Musson–De Gas household on Esplanade. Edgar is known to have been fascinated with steam-powered machinery. We have no record of Norbert being in New Orleans when Edgar was visiting. If the two men met there, it would have been in secret, as hostility, danger and injustice were simmering in 1872.

A photograph of Norbert Rillieux, a free person of color and a relative of Edgar Degas. He was an engineer well known for innovations in the sugar industry. *Collections of the Louisiana State Museum.*

Eventually, Norbert fled to Paris, finding refuge there in 1882. He remained in Paris for the rest of his life, even though his family had been such a part of Louisiana for generations. Norbert continued to invent and teach others. He served as an instructor in applied mechanics at the École Centrale in Paris, publishing revered papers on steam engines and steam power.

THE SOULIÉ FAMILY

Norbert Rillieux's mother, Constance Vivant (1794–1868), had a half sister, Eulalie Vivant (1775–1825). Eulalie married Jean Soulié (1760–1834). Their son Norbert Soulié (1793–1869)[165] became a well-known architect in New Orleans.[166] Norbert and his brothers, Lucien (1789–1862), Bernard (1801–1881) and Albin (1803–1873), were well-known businessmen who engaged in real estate for more than thirty years as B&A Soulié merchants.

In the nineteenth century, the community of free people of color was an interconnected network in New Orleans. Entrepreneurship through real estate was a community-oriented endeavor. Several structures in New Orleans built by free people of color still exist, such as the Louisiana Sugar Refinery.[167]

NORBERT SOULIÉ

We are grateful to have met Norbert Soulié through friends at the Association France-Louisiane. A French entrepreneur, Norbert also has a keen interest in ancestry research. For over two decades, he has been researching his Louisiana ancestors from his home in Bayonne, France. Norbert's family traces back to the Degas family in New Orleans.[168]

While in France, we spoke to Norbert to learn more about his family, as well as gain a French perspective on Edgar Degas in New Orleans.

We believe the climate and his significant experience in New Orleans changed Degas, as he became very successful when he returned to France. Perhaps, as New Orleanians, we are biased. What is your perspective, as a Frenchman?

There was no way a Frenchman could come over and experience the culture in the South and in New Orleans, with such different types of people, and not somehow be affected by that experience when he came back to France. He would likely always remember New Orleans and look at the distinctions between France and America.

Above, left: Norbert Soulié, a free person of color and well-known New Orleans architect. The Soulié, Rillieux and De Gas families are connected by shared ancestors. Courtesy of his descendant Norbert Soulié in France, 2022.

Above, right: Elisa Courcelle was a free person of color in New Orleans and the wife and half cousin of Bernard Soulié. She is related to Constance Vivant, Edgar Degas's great-aunt, a free woman of color. *Courtesy of Norbert Soulié, 2022.*

Right: Bernard Soulié was a free person of color in New Orleans who shared a common ancestor with Edgar Degas. He was the brother of Norbert Soulié and was a successful businessman in New Orleans. *Courtesy of Norbert Soulié, 2022.*

Sometimes, people have said Degas' time in New Orleans didn't really matter besides the one painting, *The Cotton Office*. We feel his experience was significant. What do you think?

I'm not an expert in art, but I am very interested in Louisiana. The history of Frenchman Degas, arriving with his brushes and oil paints, to meet his cousins is intriguing.

Degas was not a tourist; he did more than twenty paintings here. He was away from his family in France for six months and not in close contact with them.

In New Orleans, he discovered this civilization that was completely different than France. Everything was completely different. The atmosphere was unique. He discovered Europe was not the center of the world. He obviously was changed.

I also lived ten years abroad and know how you change from living in different places in the world. Degas must have seen how things were different—the light, the way people lived, his family, their relationships. He saw how free people of color couldn't live side by side by the whites. It was difficult to understand how whites and nonwhites lived, since it was completely different in France. How could he not have been affected?

RECOMMENDED READING

Delile, Cecile. *Degas: Un Hiver en Louisiane.* Brissac-Quince, France: Editions du Petit pavé, 2017.

Dudley, Tara. "Ownership, Engagement, and Entrepreneurship: Gens de Couleur Libre and Architecture of Antebellum New Orleans." PhD dissertation, University of Texas at Austin, 2012.

Soulié Family account book, 1850–1871. *Louisiana Digital Library*. louisiana digitallibrary.org/islandora/object/fpoc-p16313coll51%3A38440.

Taylor, Michael. LSU Libraries. lib.lsu.edu/sites/all/files/sc/fpoc/history.html.

Toledano, Roulhac, and Marie Louise Chrisovitch. *New Orleans Architecture: Faubourg Treme and the Bayou Road.* Gretna, LA: Pelican Publishing Company, Inc., 1980.

Terry Martin-Maloney

Great-great-grandniece of Edgar Degas

We also spoke with Terry Martin-Maloney, the great-great-grandniece of Edgar Degas, about the Degas family legacy. Terry and her father, Edmund Martin, were both committed to share knowledge of Degas' American family line with the world. Together, they worked hard to create the Degas Legacy website, which took about two years to write, research and design. Terry welled up when she spoke of their time together writing this legacy. There were so many more questions that she would have loved to ask her father before he passed.

Like Degas, Terry is an artist. She paints in her home studio and runs her art gallery in Sarasota, Florida. Determined to hone her talent, she attended Ringling College of Art and Design. She was raised in North Carolina, New York, Mississippi and Virginia. She worked as a graphic designer, running her own company for over forty years. A gifted painter of seascapes and wildlife, she shared with us her painting, *Blown in Shore*.

We are grateful that Terry shared her family narratives with us.

What is Terry's familial connection to Edgar Degas?

Terry is related to Edgar through her great-grandfather Edgar Gaston De Gas–Musson (1875–1953), the son of René and Estelle De Gas. Terry actually met Gaston when she was very young in New Orleans.

Gaston De Gas-Musson married and had a daughter, Dora Odile Musson Martin (1900–1986), who was Terry's grandmother.[169] Dora gave birth to Edmund Butts Martin (1924–2012), Terry's father.

Terry described her great-grandfather Gaston De Gas and shared that he made some poor business decisions like his father, René, had. Although Gaston went to France to claim his inheritance, he eventually lost his wealth. Gaston lost some money through a failed venture by investing in red kidney beans.

What did her ancestors' inherited Degas art collection include?

Terry described her great-grandfather's Degas artwork collection. Gaston had a collection of several Degas sketches and bronzes of horses, ballerinas and bathers at his house, which is now the location of the popular Brennan's restaurant in the French Quarter.

Gaston would have famous visitors to his home to see the Degas collection, including actors like Nelson Eddy and Edward J. Robinson, in the 1940s and

Blown in Shore, by Terry Martin, acrylic painting. *Courtesy of the artist, Terry Martin, a descendant of René De Gas.*

1950s. Gaston invited them to sign their names under the fireplace mantel. Terry longs to visit this house and see if this story is true or not.

Terry also described Gaston as humorous. When visitors would come to see the artworks, he had a bit of a sense of humor. He'd pretend to shake his pipe and drop ashes in the sculptures—to the horror of the guests!

What eventually happened with any of Degas' artworks that her New Orleans relatives inherited?

Gaston sold many bronzes to the Museum of Chicago in the early 1950s for about $750 apiece. Gaston later sold additional artworks because the family needed money to pay for essentials, like the costs of assisted living for a family member. And he donated an artwork by Degas to the New Orleans Museum of Art.

Terry's father was promised one pencil drawing that Degas did in New Orleans. Unfortunately, her grandmother lent the artwork to a family member, and it was never returned.

Terry also told us that according to family knowledge passed down to Terry, there were many Degas drawings in the family's attic. The family didn't think some of the sketches were of any value, so they threw them away.

How is Terry inspired and influenced by Edgar Degas?

Terry was born an artist. Art is part of her blood. Terry is very honored that Edgar Degas, the French painter, is part of her heritage. She feels Degas' works of art portray an impressionistic view of the ballet, opera and subjects involved in ordinary activities living in a city, while her artwork portrays wildlife and seascapes living in a coastal town.

In her art gallery, Terry also shares with gallery-goers a bit about her genealogy and relation to Edgar Degas. On one wall, she has created a triptych painting of Edgar Degas' *Fourteen-Year Old Dancer*. She recalled that without knowing why, she chose Degas' subject matter for her first painting in elementary school: a ballerina.

Terry's advice for artists is to "paint what you love…paint your passion, whether abstract, realism or impressionistic." When budding artists come in her gallery, some mention they are afraid to begin on a blank white canvas. She says to take a light-color paint and splatter some on the canvas. There. It's already messed up. Now you can begin!

RECOMMENDED READING

Martin, Terry. "Edgar's Link to the Musson/Martin Family." Degas Legacy. www.degaslegacy.com/15degasmartinlegacy.html.

Rewald, John. "Degas and His Family in New Orleans." *Gazette des Beaux-Arts* (1946): 105–26.

ARTWORKS CAPTURE
DEGAS' MYSTERIES

MME MUSSON AND HER DAUGHTERS, ESTELLE AND DÉSIRÉE

Edgar Degas' aunt Odile Musson, cousins Estelle and Désirée and niece Josephine sought refuge in France from 1863 to 1865. Edgar Degas immortalized their desperate visit in the brilliant "au revoir" painting *Mme Michel Musson and Her Daughters, Estelle and Désirée*. He completed the miniature portrait on January 6, 1865 (which was rare for Degas to date his works), just before they departed Bourg-en-Bresse and returned to New Orleans.[170]

This was not the first time Degas painted his sorrowful relatives. This haunting portrait of the Musson family posed before the fireplace recalled an earlier artwork, *The Bellelli Family*, in which Edgar Degas depicted his mourning Italian aunt Laure, his cousins and his uncle. Both tragic portraits are grounded in grieving and mourning.[171]

So gripping and authentic was *Mme Musson and Her Daughters, Estelle and Désirée* that it was used to determine the identity of Estelle in a later portrait, *Woman with a Vase of Flowers* (1872).[172] The seated woman, dressed in black in the foreground in the Musson family portrait, is the widow Estelle Musson Balfour. Scholars, including Jeanne Sutherland Boggs, determined that the subject in *Woman with a Vase of Flowers* indeed resembles Estelle De Gas, with her long nose and heavy jaw.[173]

Mesmerized by this artwork, we spoke with specialist Dr. Jay Clarke,[174] the Rothman Family curator of prints and drawings at the Art Institute of Chicago.

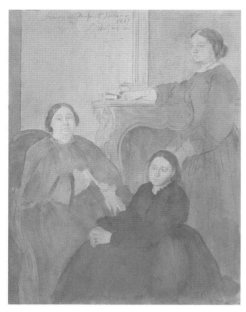

Left: *Mme Musson and Her Daughters, Estelle and Désirée. The Art Institute of Chicago.*

Below: *Portrait of Mme Lisle and Mme Loubens,* by Edgar Degas, 1866/1870. *Art Institute of Chicago, gift of Annie Laurie Ryerson in memory of Joseph Turner Ryerson, 1953.335.*

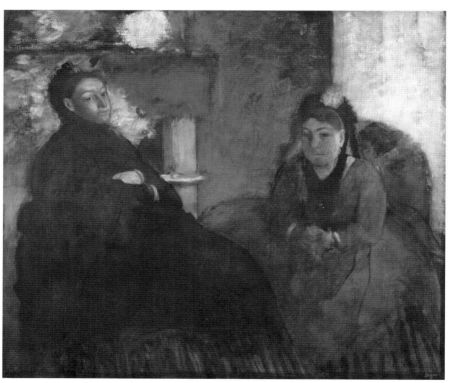

Can you share more about the processes Degas used to create this artwork?

Degas was continually experimenting with chalk, charcoal and pastel (dry media) throughout his career, but he used watercolor less frequently. He tended to use it alone or with other media in his early years. Later, he used it as an addition to pastel to make it more aqueous.

The correct media description for this drawing is watercolor with touches of charcoal and brush and red chalk wash, heightened with touches of white gouache, on cream wove paper.

Can you share with us additional information about this drawing by Degas?

The artist did sign and date the drawing in the upper left center. A red estate stamp adorns the lower right corner with the mark of the Degas atelier (L657). The same estate stamp can be seen more clearly in *The Jet Earring* (1876–77), also by Degas.

Mme Michel Musson and Her Daughters, Estelle and Désirée relates in composition to another work in the AIC collection: *Portrait of Mme Lisle and Mme Loubens* (1866–70).

RECOMMENDED READING

Boggs, Jeanne. *Degas, 1834–1917.* New York: Metropolitan Museum of Art, 1988.

Brettell, R., and S. McCullagh. *Degas: Beyond Impressionism.* Chicago: Art Institute of Chicago, 1984.

Clarke, Jay. *The Impressionist Line from Edgar Degas to Toulouse-Lautrec.* Williamstown, MA: Clark Institute, 2013.

Rondeau, James. *Treasures of the Art Institute of Chicago: Paintings from the 19th Century to the Present.* New York: Abbeville Press, 2018.

Schenck, Kimberly. "An Experiment in Pastel and Watercolor by Degas." National Gallery of Art, November 17, 2020. www.nga.gov/blog/pastel-watercolor-degas.html.

THE COTTON MERCHANTS

Edgar Degas visited his family's cotton office frequently while he was in New Orleans and found it to be an inspiration for his artwork. In a letter, Edgar was excited about the idea he had for *The Cotton Merchants*, which he

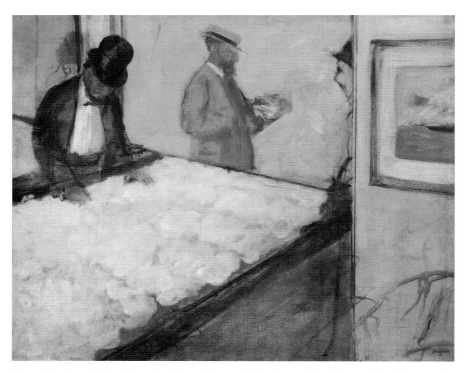

Cotton Merchants in New Orleans, by Edgar Degas, 1873. *Harvard Art Museums/Fogg Museum, gift of Herbert N. Straus, Photo ©President and Fellows of Harvard College, 1929.90.*

described as more "spontaneous." In the artwork, while merchants inspect cotton, behind them on a wall is an ocean painting. Scholars suggest the artist may have been referencing "a sea of cotton."[175] The sea also refers to the transport of cotton by ships on the ocean from America to Europe.[176]

Degas created two paintings focused on cotton: *The Cotton Office*, which is housed in a French museum in Pau, and *The Cotton Merchants*, which resides in America in the collection of the Harvard Art Museums.

The focus on cotton is quintessentially Edgar's experience in America. His strategic planning for the sale of his cotton painting while in New Orleans showed his shift to businessman and entrepreneur in the business of art.[177]

Enamored by this artwork, we spoke with specialist Kate Smith, conservator of paintings and head of Paintings Lab at the Harvard Art Museum.

Can you describe about materials and techniques that Degas used when creating this painting?

The canvas is 24 threads per centimeter and is 71 x 58 centimeters in dimension, close to the French standard size. There is a light white ground layer that extends to the tacking edges; it appears to be commercially prepared.

The initial sketch was laid in with very fluid dark paint, some brown, some black. The very thinly worked paint only partially covers the sketched lines and ground layer; not all sketched forms were executed in paint.

Further artist changes were revealed by X-radiography and infrared reflectography, both of which suggest that Degas experimented with the location and number of figures, removing some as the painting progressed.[178]

RECOMMENDED READING

Brown, Marilyn. *Degas and the Business of Art: A Cotton Office in New Orleans.* University Park: Pennsylvania State University Press, 1994.

Hensick, Teri. "Process or Product?" In *Dear Print Fan: A Festschrift for Marjorie B. Cohn,* edited by Craigen Bowen, Susan Dackerman and Elizabeth Mansfield. Cambridge, MA: Harvard University Art Museums, 2001, 153–59.

Smith, Kate. "Copley's Working Practice." In *The Philosophy Chamber: Art and Science in Harvard's Teaching Cabinet, 1766–1820,* edited by Ethan Lasser, 224–35. Cambridge, MA: Harvard Art Museums, 2017.

DEGAS' PASTELS

In Paris, we continued our research at the Musée D'Orsay, examining two Degas New Orleans artworks that are on permanent display: *Woman with a Vase of Flowers* and *The Pedicure*. The D'Orsay's expansive collection of Degas' works is truly phenomenal.

We were interested in studying any differences in the style, subject matter and materials that Degas used when he immediately returned to Paris from New Orleans. I (Rory Schmitt) also had the opportunity to view some of Degas' pastel artworks, currently not on display in the museum.

While viewing these pastel drawings, I spoke with Dr. Caroline Corbeau-Parsons, the curator of drawings/conservatrice des arts graphiques at the D'Orsay.[179] There are fifty-five thousand drawings in the Musée D'Orsay collection. She oversees all of them. Dr. Corbeau-Parsons shared about

the delicate nature of pastel drawings.[180] Degas' pastel drawings are quite special and must be particularly cared for in ways recommended by the museum conservators. For instance, pastels must be displayed flat, not on a wall, with special framing and padding and glass. These types of artworks are carefully protected, as pastels are more affected by vibration than light. The vibrations lift the pastels off the paper.

In the museum storage room, Dr. Corbeau-Parsons showed me a small pastel drawing, *Woman Getting Out of the Bath* (1876), which Degas created on top of a monotype. Degas was introduced to monotypes in the mid-1870s, after returning from New Orleans. The process of making

Opposite: *Rosary with the Little Fourteen-Year-Old Dancer*, 2019. *Photograph by Rosary O'Neill.*

Left: *Woman with a Vase of Flowers and Rory O'Neill Schmitt*, 2022. *Photograph by Rory O'Neill Schmitt.*

monotypes involved drawing on a metal plate and then running it through a press, resulting in a print. For this artwork, Degas added layers of pastels on top of a monotype, a type of crude silhouette. Monotype wasn't a constant for Degas; it was a starting point. He was always experimenting with approaches to making art, exploring methods of using pastels and returning to rework his drawings.

When I was viewing this artwork, Dr. Corbeau-Parsons asked me, "It's smaller than you expected?" "Yes," I answered, "but more beautiful." As I leaned over the table to get a closer look, I spotted Edgar's fingerprint, a smudge on the pastel. It made me feel closer to him for a second because it wasn't a brushstroke; rather, it was a small effect of his physical body, like the way you'd breathe on glass in the cold.

Dr. Corbeau-Parsons explained that Degas drew both bourgeoisie ladies and prostitutes. For this drawing, it was a bourgeois woman. "How can you tell?" I asked. "If you look at other drawings using this same monotype, you can see how the faces are different." She referred me to a catalogue, *Degas and the Nude*, which describes these artworks and the monotype process in greater detail.

As I further looked at this pastel drawing, I could see the woman exiting the tub, her skin pale with pink tones. Degas treated the complexion almost reverently. A woman assists the bather out of the bath, covering her with a towel from behind. There's a large armchair just outside the tub, and he's used yellow and brown colors, creating this cozy texture and warm feeling of a chair you could just melt into. Perhaps another private scene.

Degas' perspective of the bathroom scene reminds me of other bather artworks. It's like a keyhole view of a private moment; no one knows he is there. He was determined to capture an intimate everyday peaceful moment, one that maybe we take for granted. In New Orleans, he also captured intimate scenes within the home, such as *The Pedicure*, of his niece Jo.

Dr. Corbeau-Parsons showed me the second pastel I requested to see, *Ballet* (1876).[181] I asked, "Why isn't this one on display?" She explained that usually when artworks are loaned to other institutions to display, the conservators recommend a three-year period where they must "rest." Wow—a pastel is like a dancer who needs to rest after a performance. This pastel had performed, and it needed to break, too.

In this pastel artwork, we see on stage a dancer with her lifted leg in the air, arms up in a graceful position, chest exposed, a beautiful décolletage, her neck adorned with the black ribbon chokers we often see in Degas' works. To the left, behind the dancer, stands a man waiting in the wings. We see only part of his body, it being cut off by the curtain. He watches the dancer performing her solo. Behind him stand other dancers waiting in the wings for the dancer to complete her solo. It seemed to me a metaphor: everyone gets her chance to dance and be seen. We all have to wait in the wings for our turn. It's a shared human experience.

Dr. Corbeau-Parsons pointed out the perspective of the curtains, the treatment of the decor, the way the layers line up, the different planes and textures. I noticed a landscape of trees as a backdrop for the stage. Different colors, movement, line qualities. She explained this painting was a monotype, as well. She pointed out, for instance, the standing foot of the soloist. He drew over it to the left to have the foot point a different direction; you can still see the original spot where the foot was on the monotype.

With these two pastels, Degas was experimenting, taking the monotype as a starting point to make something new from a copy of something old. He created alternatives with such fervor. In New Orleans, he didn't

Sculpture at the Musée D'Orsay, 2022. Photograph by Rory O'Neill Schmitt.

use monotypes; every sketch was started from scratch, which was more time intensive.

Degas' subjects continue to captivate the world 150 years later, as do many ancient marble sculptures housed in the museum's collection.

RECOMMENDED READING

Corbeau-Parsons, Caroline. *The EY Exhibition: Impressionist in London: French Artists in Exile.* London: Tate Publishing, 2017.

Degas and the Nude. Paris: Musée D'Orsay, 2012.

"Edgar Degas: A Strange New Beauty." MoMA, 2016. www.moma.org/calendar/exhibitions/1613.

"Pastels: History of the Pastel Collections." Musée D'Orsay. www.Musée-orsay.fr/en/node/506/pastels.

THE ART OF THE LETTER

The Musson-Degas letters expose even more about the Edgar Degas story in New Orleans. The hopes and expectations of Edgar and his brother René seem naively romantic—knowing the cruel ending of their saga. Through this narrative, we share excerpts from Degas and Musson family papers, with our gratitude to Tulane University Special Collections.

1861: A Few Years Prior to the Mussons' Exile in France

Edgar's father, Auguste De Gas, was in close contact with the Musson family, often sharing family news and concerns. Edgar was twenty-seven years old, and his father was worried about his career as an artist. In November 1861, Auguste wrote to his brother-in-law Michel, "Our Raphael is always working, but hasn't yet produced anything accomplished, meanwhile, the years go by." Auguste had always championed Edgar's artistic development and career, but it seems he feared that he wouldn't become successful.

During the Civil War, the De Gas brothers cared deeply about their Musson relatives in Louisiana and were concerned for their safety in their letters. René and his sister, Marguerite, expressed concern about the "Yankee campaign" against New Orleans.

René shared both Edgar's fixation on painting and his desire to see his New Orleans family. He wrote to Uncle Michel: "Edgar is so absorbed by his

painting that he writes no one in spite of our remonstrances. That doesn't keep him from thinking of you often and very much wanting to see you. When will his wishes, which are also ours, be realized?"

René even mentions the family's love of music and dedication to learning instruments, reporting, "The violin lessons proceed, but very slowly. It's atrociously difficult. Edgar is learning it, too."[182]

1863–1865: THE MUSSON LADIES ARE CIVIL WAR REFUGEES IN FRANCE

Just a few years later, the Musson ladies arrived in France as war refugees. In June 1863, Edgar wrote to Uncle Michel: "My dear uncle, your family arrived here last Thursday 18 June and is now completely ours. Things couldn't be better, or simpler. Accept all my warm regards."

The families shared photographs by mail. Edgar wrote, "Your photograph is definitely you, although it conveys less of the air of humor of which René has frequently spoken, an air which I can scarcely find [in the photograph]."

A devoted nephew, Edgar reported on the health of Uncle Michel's wife: "Our aunt Odile is walking very well and I admit that, judging from the portrait we have of her, I expected her to be less spry. Didi is really her first mate."

Additionally, Edgar showed deep compassion for his cousin, the widow Estelle: "As for Estelle, poor little woman, it's hard to look at her without thinking that her head has hovered before the eyes of a dying man. Please give our warm regards to the pleasant and pretty Mathilde."[183]

Just a few months after arriving in Bourg, Didi shared that René was planning on moving to New Orleans after the war ended to seek his fortune. She wrote to her father:

> *Mother requests me to say to Papa that he should pay attention to the manner in which he writes to René on the subject of his departure for America; René is a charming boy, full of intelligence, ambition, and heart. He has only one idea, and that is to leave his father's banking firm to go to work and live with us; he says if he stays in Paris, or if he goes to Naples* [to work for the branch of the family bank there], *he will wait for 50 years, earning 30 francs a month; this revolts him. He would rather arrive at 30 years, be his own master in all things; and to make a fortune from life....*

> *However ardent to attain his goal, he will have to speak and reason a lot before obtaining the consent of his father....Edgar is the only one who encourages René, because he knows all that he suffers from his position, with perhaps no future.*[184]

Edgar and Marguerite adored the Mussons and visited them in Bourg. Marguerite relayed her growing bond with her aunt and cousins to Uncle Michel, writing, "Edgar left from here yesterday to go spend the new year holidays with them, and he is so gay that he will amuse and entertain them a bit. He took with him a lot of pencils and paper to draw Didi's hands in all due form, because it is rare to find so pretty a model."[185] Even when visiting family, Edgar persisted in creating artwork and posing his cousins.

1864: THE MUSSON AND DE GAS FAMILY BOND GROWS IN FRANCE

René's desire for closeness to the Mussons grew, as did his determination to voyage to New Orleans. Cousin Didi warned her father that René was doggedly ambitious and likely would succeed regardless.[186] René wrote to Uncle Michel, "Willy nilly, you will see me arrive there & then you will make me into what you wish, a cotton planter or a wholesaler."[187] But Michel was reluctant for René to move to New Orleans, as was René's father, who warned him about the potential dangers and wanted to send him to England.

René held firm on his preference to an apprenticeship in a cotton firm rather than a bank.[188] Auguste continued to encourage René and Achille to work at the family banking firm in Naples. They declined, worried they would be under the shadow of their uncle. Plus, René couldn't possibly see how he could discover his millions through being a simple money changer at a bank.

Brotherly love abounded between Edgar and René. When his father didn't support René's decision to seek his fortune in New Orleans cotton with his uncle, it was Edgar who supported him. As an artist, Edgar deeply empathized with a personal calling that fought family expectation.

René wrote to Uncle Michel: "In short, I am more decided than ever to go to work with you & when we can chat in person you will see that I have done perfectly well to make this decision. Edgar, who knows the family, said it well when he told me that if I want to become something, I must completely

detach myself with respect to advantage, and depend on them only with respect to affection."

Edgar and René were like best friends. René continued, "He is distressed to see me go because we love each other a lot but he well understands that I will find my life over there rather than here."

René often signed his letters to show his devotion, including this one to his uncle: "Yours forever."[189]

1866: RENÉ DE GAS' DISASTROUS FINANCIAL FAILINGS

René's lies and conceit are preserved in his letters. His disastrous debt weakened his father's bank and continued to plague his family's finances until the liquidation of the family bank in the 1870s.

In 1866, René experienced a huge financial loss in cotton speculation, and he kept it a secret from his siblings. He wrote to Uncle Michel:

> *I am not saying anything about it to the family, that would only ruin me &*
> *at this time I need all their good graces. I will make up that money sooner*
> *or later, but to begin life with debts & to engulf the fortune of my brothers*
> *& sisters from the outset,* ça n'est pas gaie. *I am completely dazed for the*
> *time being, but that will pass.*

One wonders if he felt sorrow for his mistakes. He wrote, "What an odd fish I make; now I can only get used to this European life again with some difficulty. Old, foggy, stingy, & egotistical, that is all one sees, all one meets....Well, I love you all dearly. Even though I am often as loveable as a porcupine, I will try to be nicer but I will come back and hope to succeed there."

Finally, René determined that Louisiana was his salvation: "Living in New Orleans, it is the country of young men who have nerve."[190]

1872: RENÉ'S RETURN WITH EDGAR

René and Estelle married in 1869 in New Orleans. While abroad, he frequently wrote to her. In 1872, René shared with her updates about Edgar, "who has matured, some white hairs sprinkling his beard, he is just as stout and more rested."

René truly admired Edgar's skill as an artist: "Edgar is really doing some charming things. He has a portrait of Mme. Camus in profile in a garnet red velvet dress, seated in a brown armchair against a pink background which, for me, is purely a masterpiece. His drawing is something ravishing."

By this time, Estelle had already experienced vision loss and light sensitivity, which ran in the family. René reported Edgar's eye struggles. He wrote to Estelle, "Unfortunately, he has very weak eyes, he is forced to take the greatest precautions.

René described his brother's artwork:

> *Edgar is making small paintings of dress rehearsals, which is difficult for his eyes. His eyes are better, but he has to spare them and you know how he is. Just now, he makes small pictures, which is what tires his eyes the most. He is doing a dance rehearsal which is charming. As soon as the picture is finished, I'll have a large photograph taken of it.*

The brothers spent much time together, socializing and having fun. Edgar was "crazy to learn to pronounce English words, he has been repeating *turkey buzzard* for a whole week."

René mentioned, "I have lunch at his place every day. He has a good cook and a charming bachelor's apartment....Yesterday, I dined at Edgar's with Pagans, who sing with guitar accompaniment. Achille will give you some details on him."

As they spent much time together, Edgar noticed changes in René. René explained to his wife, "Edgar thinks me an American, & I also feel completely foreign."[191]

René was eager when he shared, "Edgar has got it into his head to come with me and to stay with us for a couple of months. I couldn't ask for better. He contemplates all sorts of things about the natives and never stops asking questions about you all. I decidedly think that I'll bring him back."

René proudly shared, "Prepare yourselves to give a fitting reception to the Great Artist."[192]

1873: Enchantment in New Orleans

René continued to believe in his brother's extraordinary talent, but there was an air of sibling rivalry that he shared in writing to Uncle Michel: "He is, as

you say, an amiable boy who, moreover, will become a very great painter if God preserves his sight and makes him a little less feather-brained."

When Edgar returned to France after his time in New Orleans, he was enchanted. René excitedly wrote to Uncle Michel of Edgar's captivation with New Orleans: "Edgar came back to us enchanted by his voyage, enchanted to have done so many things new to him, but especially enchanted to have made the acquaintance of all his good relatives in America."[193]

ADDITIONAL FAMILY TREE
INFORMATION

Hilaire De Gas (1770–1858) married Aurora Freppa (1783–1841)
Their children were:
> Rose De Gas Morbillli (1805–1878)
> Auguste De Gas (August 19,1807–February 23, 1874)
> Henri De Gas (1811–1878)
> Jean Eduard De Gas (1811–1870)
> Charles De Gas (1812–1875)
> Emilie De Gas (1819–1901)
> Anne Laurette De Gas Bellelli (1814–1887)

Auguste De Gas (August 19, 1807–February 23, 1874) married Célestine
Musson (April 10, 1815–September 5, 1847)
Their children were:
> Edgar Degas (July 19, 1834–September 27, 1917)
> Achille De Gas (November 16, 1838–February 23, 1893)
> René De Gas (May 6, 1845–April 30, 1921)
> Marguerite De Gas Fèvre (July 2, 1842–October 2, 1895)
> Georges De Gas (December 25, 1835–1837)
> Marie Thérèse De Gas (April 8, 1840–1912)

René De Gas (May 6, 1845–April 30, 1921) married Estelle Musson (July 16, 1843–October 18, 1909)
Their children were:

> Michel Pierre Auguste De Gas (April 6, 1870–April 11, 1881)
> Odile De Gas–Musson (October 27, 1871–March 31, 1936)
> Jeanne De Gas (December 20, 1872–October 4, 1878)
> Edgar Gaston De Gas–Musson (February 23, 1875–January 5, 1953)
> Rene Henri De Gas (September 2, 1876–March 13, 1877)

Estelle Musson was first married to Joseph Balfour (1842–1862)
Their child was:

> Josephine Balfour (October 27, 1862–April 18, 1881)

Germain Musson (November 13, 1787–May 10, 1853) married Marie Céleste Rillieux (July 1, 1794–July 16, 1819)
Their children were:

> Michel Germain Musson (January 13, 1812–May 4, 1885)
> Anne Musson (August 20, 1813–May 6, 1857)
> Celestine Musson (April 10, 1815–September 5, 1847)
> Louis Eugène Musson (1817–?)
> Henri Germain Musson (May 10, 1819–July 12, 1883)

Michel Musson (January 13, 1812–May 4, 1885) married Odile Longer (August 9, 1819–August 31, 1871)
Their children were:

> Désirée Eulalie "Didi" Musson (December 6, 1838–April 7, 1902)
> Eugène Musson (January 6, 1840–September 5, 1849)
> Mathilde Musson (December 28, 1841–September 21, 1878)
> Estelle Musson (July 16, 1843–October 18, 1909)
> Michel Germain Musson (January 11, 1852–February 10, 1854)
> Germaine Odile Musson (September 3, 1853–September 7, 1853)
> Joseph Germain Musson (March 20, 1855–July 22, 1859)

A LIST OF DEGAS' NEW ORLEANS FAMILY ARTWORKS

Mme. Michel Musson and Her Two Daughters, Estelle and Désirée
Edgar Degas
1865
Gift of Margaret Day Blake, 1949.20, The Art Institute of Chicago

Portrait of Estelle Musson Balfour
Edgar Degas
1865
The Walters Art Gallery, Baltimore

Mme. René De Gas
Edgar Degas
1872
© Board of Trustees, National Gallery of Art, Washington, D.C.

Portrait of Estelle Musson Degas
Edgar Degas
1872
New Orleans Museum of Art

Woman Seated near a Balcony
Edgar Degas
1872
Ordrupgaardsamlingen, Copenhagen

Children on a Doorstep (New Orleans)
Edgar Degas
1872
Ordrupgaardsamlingen, Copenhagen

Woman with a Vase of Flowers
Edgar Degas
1872
© Photo Reunion des Musées Nationaux

The Song Rehearsal
Edgar Degas
1872–73
Dumbarton Oaks Research Library and Collections, Washington, D.C.

The Artist's Cousin (Probably Mrs. William Bell)
Edgar Degas
1872–73
The Metropolitan Museum of Art, H.O. Havemeyer Collection

The Nurse (La Garde Malade)
Edgar Degas
1872–73
Private Collection, Courtesy of Walter Feilchenfeldt

Achille Degas
Edgar Degas
1872–73
Minneapolis Institute of Arts

Woman with a Bandage
Edgar Degas
1872–73
The Detroit Institute of Art

The Convalescent
Edgar Degas
1872–87
Collection of John Loeb, New York

Cotton Merchants in New Orleans
Edgar Degas
1873
Courtesy of the Fogg Art Museum, Harvard University Art Museums, Gift
 of Herbert N. Straus

A Cotton Office in New Orleans
Edgar Degas
1873
Municipal Museum, Pau, France

The Pedicure
Edgar Degas
1873
© Photo Reunion des Musées Nationaux

GOODBYE, EDGAR

Au revoir, Edgar. We want to weep, to scream: *Don't go!*
Don't leave us here in our streets flooded with tears, our sobbing Mississippi River embracing all the souls lost, all the dreams never realized, all the striving fruitless.

Do not go, Edgar. You are one of us.

It's a comforting womb, New Orleans. We have everything you want here, need—well, almost. We tried, at least. We gave you memories that would last a lifetime. And now, 150 years later, our hearts still ache.

We're claiming you, Edgar, as one of our own, one of our Louisiana sons. We hope you don't mind.

We want the world to know your mother was American, and that makes you ours. Well, at least half ours. We'll take the better half.

NOTES

Chapter 1

1. Célestine Musson De Gas (1815–1847)
2. Marie Céleste Rillieux Musson (1794–1819) came from a distinguished New Orleans family of French heritage who had resided in Louisiana for generations.
3. Michel Musson (1812–1885)
4. Germain Musson (1787–1853) was the son of French immigrants. He moved to New Orleans in 1809, seeking to build his fortune. He was fleeing erupting revolutions in Port-au-Prince. Germain dared a new life in New Orleans, where the city's population was skyrocketing from fourteen thousand to twenty-four thousand people. For additional information about the De Gas and Musson families, refer to Benfey, *Degas in New Orleans*.
5. Musson exported cotton and sugarcane to textile mills in Massachusetts. His ships returned to New Orleans with ice from New England ponds to sell.
6. b. 1812
7. b. 1813
8. b. 1815
9. b. 1817
10. b. 1819
11. Auguste De Gas (1807–1874)
12. Hilaire De Gas (1770–1858) was a wealthy entrepreneur who had made his money in bold ventures after the French Revolution.
13. The De Gas family was steeled for brilliant marriages. One sister married an Italian nobleman with the immodest title of Ducca di Sant'Angelo a Frosolone. Another sister married the grandson of a marquis. Auguste De Gas decided not to marry a rich Italian heiress but instead chose a French-Louisiana lady whom

he discovered in his garden. Célestine's father was overjoyed by their union. With wealth acquired from his booming cotton business in New Orleans, he gave Célestine a more than respectable dowry and celebrated the family's good fortune.

14. Edgar's surnames were for his two grandfathers.

15. This portrait now hangs in The Historic New Orleans Collection.

16. Victorian decorum involved pregnant women being confined. Many lived in dread of dying in labor. Women had on average seven children and expected to bury at least one. There were no painkillers when giving birth, so childbearing was an agonizing experience. Women needed to be healthy and strong to survive. Not infrequently, death in relation to childbirth occurred in fit young women, too, who were quite well before becoming pregnant.

17. b. 1838

18. b. 1840

19. b. 1842

20. b. 1845

21. Georges De Gas (1835–1837)

22. *The Adoration of the Magi* (c. 1475) was a depiction of the Medici family. The painting's artist, Botticelli, included a portrait of himself standing on the extreme right corner in the painting.

23. Jean-Auguste-Dominique Ingres (1780–1867)

24. Similarly, Rory, coauthor of this book, began studying drawing at age fourteen, weekly drawing in studio with a local New Orleans painter, Mike Willmon. Visits to New York City and Paris taught her she had to start drawing regularly and learning early if she wanted to specialize in art.

25. In the 1850s, Edgar was studying art in Italy. He painted his Italian relatives in *The Bellelli Family* (1858–69). His father wrote to Edgar, urging him to finish the family portrait and return. Edgar had been postponing his return home, a behavior he'd repeat in New Orleans.

26. For more information, refer to Auguste De Gas's letter to Michel Musson, 1861, *Degas-Musson Family Papers*.

Chapter 2

27. Germain Musson Bell (1863–May 12, 1865)

28. Didi (Désirée) Musson traveled to France earlier than her trip in 1863, but there is little documentation. In the Musée D'Orsay library archives, there is a drawing of Didi by Degas in the 1850s. So Edgar had met her in person in Europe prior to 1863 in Bourg-en-Bresse.

29. Edgar wrote in a letter to Uncle Michel in 1864.

30. When there was a casualty during the Civil War, families were notified by letters. During an interview with Dr. Justin Nystrom, we learned one standout about the Civil War was how well the postal service worked. The Confederate Postal Service would get interruptions, but as the war went on, even bags of mail would

be exchanged between the Union and the Confederacy. Mail was always regular. It's one of the reasons why historians know so much about the average Civil War soldier—because so many of those letters survived. Interview with Dr. Nystrom, August 2022.

31. 3:1 was the rate of Confederate deaths to Union deaths. Southerners also stood a significantly greater chance of being killed, wounded or captured.

32. This painting went by another name, *The Misfortunes of the City of Orléans*, when exhibited at the Petit Palace in 1918. Scholar Hélène Adhémar traced the title to a misreading. In French, *nouveau* (meaning "new") can be abbreviated as *nlle*. A similar-looking abbreviation for *ville* (meaning "city") is *vlle*. If Edgar wrote in his notes *nlle*, was he meaning to signify the painting as misfortunes of *New Orleans*, Louisiana, rather than a fictional account of atrocities committed in *Orléans*, France?

33. In May 1862, New Orleans, where Edgar's maternal family resided, came under the control of the Union military. Historical accounts show that many of these soldiers treated the women there with deep cruelty. According to research, no account of such a precise event of war atrocities against women happened in Orléans, France, but there were atrocities against women in New Orleans. For additional information on the treatment of southern women and the climate of New Orleans after the Civil War, refer to Benfey, *Degas in New Orleans*.

34. We are grateful to Dr. Barbara Bloemink, art history scholar, for her confirmation in this matter of our New Orleans interpretation of this artwork.

35. candied chestnuts

36. During the war, it was difficult to get any commerce in and out of New Orleans. When the city fell, materials stored in warehouses were able to be sold. The cotton commerce began right away. Interview with Dr. Justin Nystrom, August 2022.

37. Interview with Dr. Justin Nystrom, August 2022.

38. By the end of the war, New Orleans had grown to 168,000 people. Many free people of color and northerners moved to New Orleans. The city was a very wealthy place, as one of the country's major ports. And now, it was probably cleaner than it had ever been. Interview with Dr. Justin Nystrom, August 2022.

39. Before their departure, Edgar created a pencil and watercolor artwork. As if he was documenting them in that space and time, he labeled the painting "Bourg-en-Bresse/January 6, 1865/De Gas." It was rare for Edgar to date his works. Pictured in this painting are somber Estelle, whose black mourning dress extends to the lower black border of the picture; Aunt Odile, the central matron; and the ever-supportive Didi in the background. The space is desolate, with few details and furnishings of their rental home, just a mantelpiece with a stack of books.

Chapter 3

40. It was believed that first cousins shouldn't marry—although people in their family had intermarried for years. The couple was granted a special

dispensation from the bishop and wed on Tuesday, June 17, 1869. The Catholic service took place at Notre Dame de Bon Secours, an American wedding completely in French.

41. Cherishing his De Gas family, Michel saved all letters between the De Gas and the Musson families (some 435 of them). He likely yearned for a son to carry on his legacy, but after seven children, only his three daughters survived. Uncle Michel had buried four sons, ages nine, four, two and an infant death.

42. This amount was about $245,000 in 2022.

43. "It isn't happy," René wrote to Uncle Michel about the failure.

44. The De Gas Brothers business specialized in the export of cotton, wine and other goods.

45. Many merchants in New Orleans had been tied to slavery because their industries, like cotton, were tied to agriculture. Agriculture was slavery-based. Interview with Dr. Justin Nystrom, August 2022.

46. René would travel back and forth to France like Uncle Michel, who visited Europe for his inherited international cotton business and maintained ties with the family.

47. Back then, neither his family nor Edgar knew that he would transform his art into a business. Broken New Orleans would catapult the new path.

48. While in New Orleans, Edgar frequently mused on becoming a husband and father in letters to his friends.

49. Germain Bell (1863–1865)

Chapter 4

50. The week Edgar arrived in New Orleans, forty-three people died from cholera. As it was a port town, diseases were often brought into New Orleans, including tuberculosis, smallpox and the plague.

51. Edgar Degas served in the French National Guard in 1870–71. Additional artist friends, including Manet and Rouart, also served in the war. At rifle practice, Edgar couldn't make out the target and discovered his right eye "useless." He realized he wouldn't be a sharpshooter.

52. The house at 2306 Esplanade Avenue currently operates as a historic, legacy bed-and-breakfast and historic museum house called the Degas House.

53. Michel Musson invested heavily in Confederate bonds, as did Auguste De Gas. Michel experienced a financial disaster. He lost the family's mansion on Third and Coliseum and the Fallback Plantation in Mississippi, which Estelle had inherited from her late husband.

54. Désirée had been engaged, but her fiancé died in the Civil War, according to one account.

55. It was hard to get medical care in New Orleans. Many locals used a free clinic, run by the Sisters of Charity, but it was overrun.

56. Before the widespread recognition that bacteria was a major cause of illness, many grim realities existed: 30 percent of pregnant women miscarried; 20 percent of infants died before age one; 28 percent died before age five.

57. When the Musson girls lived in France during the Civil War, Didi described René as *l'enfant terrible*. He was like an out-of-control, wild, horrible baby.

58. Edgar wrote in a letter to Dihau.

59. Edgar wrote in a letter to Frolich.

60. Edgar wrote in a letter to Rouart.

61. In so doing, Degas became one of the most prolific draftsmen of the nineteenth century, alongside his mentor, Ingres.

62. Edgar wrote to Frolich in November 1872: "Our cousin is blind, poor thing, almost without hope." Her blindness was terrifying because Edgar had the same genes and his eyes were weak. He tried to console himself by telling Tissot in November, "My eyes are much better. I work little, to be sure, but at difficult things."

63. While living in Bourg-en-Bresse (1863–65), Estelle was experiencing some trouble with her eyes. Seeking healing, she made a pilgrimage to Lourdes. She had lost vision in her left eye by 1869.

Chapter 5

64. Both Estelle and Mathilde had given birth the year before when their mother died.

65. The ideal Victorian silhouette demanded a narrow waist, which was accomplished by constricting the abdomen with a laced corset.

66. Victorian clothing also caused poor circulation and could prolapse the uterus.

67. Mathilde (thirty-one), who had already buried a child and had three children; Didi (thirty-four), who cared for her father and nieces and nephews; and Estelle (twenty-nine), the mother of three and pregnant with a fourth.

68. William Bell was the husband of Edgar's cousin Mathilde Musson.

69. Prostitution was not illegal in New Orleans. Basin Street, where most of the bordellos were located, was only a short walk away from where Edgar lived. In France, prostitution was regulated by the state. By 1810, Paris alone had 180 government-approved brothels.

70. The racetrack in New Orleans opened in 1872, and the fairgrounds were open from Thanksgiving to early spring. William Bell rose to officer status so frequently was he there.

71. René De Gas, Will Bell and Michel Musson were active members of a racist political organization in New Orleans.

72. In his last letters from New Orleans, Degas conveyed subject matter that inspired him in New Orleans but for which would take ten lifetimes. This quote was from his last letter to Tissot.

73. With Rouart, Edgar shared, "The beautiful, refined Indian women behind their half opened green shutters, and the old women with their big bandana kerchief going to market.… The orange gardens and the painted houses attract too, and

the children all dressed in white and all white against black arms, they took attract. But wait! Do you remember in the *Confessions*, toward the end, Rouseau... at last free to dream in peace, observing impartially, beginning work that would take 10 years to finish and abandoning it after 10 minutes without regret? That is exactly how I feel. I see many things here, I admire them. I make a mental note of their appropriation and expression and I shall leave it all without regret. Life is too short and the strength one has only just suffices."

74. For additional information, refer to Marilyn Brown's chapter in the book *Sweet Spots*.

75. We completed further research about Degas' New Orleans family artworks in the Musée D'Orsay library. We examined decades of exhibition publications that included these specific Musson and Degas family artworks. Special thanks to Mary Anderson for providing translation from French to English of resource materials. When looking at the portrait of *Woman Seated on a Balcony*, we recognized Estelle and wanted to further investigate the identity of the woman in the portrait. While researching, we found that the title of this painting identified Estelle, not Mathilde, for 126 years, from 1873 to 1999.

 Studying works in the library's archives enabled us to examine the identification of the subject in *Woman Seated on a Balcony, New Orleans* (1872–73) in the Ordrupgaard Museum. We found several early documentations (1948–1999) that indeed labeled the figure as Estelle. And, in 1948, documentation by P.A. Lemoine in *Degas et son Ouevre* titled the pastel drawing *Mme René De Gas (Estelle Musson)*. The Metropolitan Museum titles its preparatory drawing for this painting *The Artist's Cousin, Probably Mrs. William Bell* (Mathilde Musson, 1841–1878). The website states, "The women can be difficult to tell apart, but the tilt of the head and the intelligent, sidelong gaze seen here closely resemble the figure of Mathilde in another, more finished pastel (Ordrupgaard, Copenhagen)."

76. Mathilde gave birth to one of six children earlier in 1872. Otherwise unwell, she died five years later at the age of thirty-seven, along with her newborn.

77. In New Orleans, Degas painted Estelle's portrait four to five times and in France twice. One wonders, were there other family members Degas painted more than seven times? Were there other models/dancers he painted more often than Estelle?

78. Estelle eventually lost total vision, and she became completely blind in 1876.

79. During this time, widows who remarried could have their funds compromised. Many women endured their husbands' control with no way out. Orphaned children were eligible for assistance, but nothing was guaranteed.

80. In New Orleans, a camelback house is a variation of the single-floor shotgun home. In the rear of the shotgun house, a second floor has been built, which looks like a camel's hump.

81. Edgar considered the painting *Children on a Doorstep (New Orleans)* sufficiently important to exhibit in the Second Impressionist Exhibition, along with *A Cotton Office*. Degas exhibited and signed this painting, a rarity, which indicated he believed in it completely.

82. America and Leonce Olivier's house was located at 1222 Tonti Avenue.

Chapter 6

83. The piano dominated the front parlor, which dominated the house. In the nineteenth century, the piano was popular in many homes because it was useful as both a solo instrument and gathered a group of singers or instrumentalists together. To accommodate home use, smaller pianos were created. In fact, René sent a piano over from Paris as a gift, replacing the large Chickering with a smaller Pleyel.

84. Edgar shared about his experience in New Orleans: "The lack of opera is a real privation." The few performances Edgar did see were terrible. Edgar yearned, "I need music so much." And he complained, "There is no opera here this winter. Yesterday evening, I went to a rather monotonous concert, the first of the year. A Madame Urto played the violin with some talent but rather monotonously accompanied and there is not the same intimacy at a concert, here especially where the applause is even more stupid than elsewhere."

85. Estelle's daughter, age ten, and niece, age five, were so in need of learning to play. Home life was centered in the intimate nineteenth-century parlor, where children played and learned with adult supervision and where the family entertained company. Solo performances were popular and included everything from opera to sentimental love songs and ballads. With the rise of the parlor as the center of life, music education became increasingly valued. Some thought playing an instrument was more important than learning to read. When guests and potential suitors visited, children would entertain with performances of the latest popular works.

86. Estelle and America probably bonded over music initially. As Estelle's vision deteriorated, she could barely read sheet music. She had comic operas like "The Loves of a Devil," sad ballads like "Soon in the Cold Neglected Tomb" and love songs like "My Soul to God, My Heart to You."

87. Edgar's father, Auguste De Gas, was in close contact with the Musson family and often shared family news. Edgar was twenty-seven, and his father was concerned about his career as an artist. In November 1861, he wrote to Michel Musson, "Our Raphael is always working, but hasn't yet produced anything accomplished, meanwhile the years go by." *Musson-Degas Family Papers.*

88. With acknowledgment to Dr. Barbara Bloemink for her close reading of *The Song Rehearsal* and her interpretation of Degas' depiction of music in this painting.

89. On February 23, America's baby, Victor Frederick Olivier, was born.

90. At this time, nearly half of all children died before they reached the end of puberty.

91. Two-thirds of Estelle's children would not survive to adulthood: Jo, Pierre, Jeanne and René.

92. One in eight women died in childbirth, an experience that was often referred to as a woman's "time of trial."

93. The exception was opium, which was rarely used.

94. Estelle, like other mothers at the time, likely labored at home with the help of family and midwives, who lacked formal training. Few pregnant women had

any contact with a medical practitioner before going into labor. Doctors were a last resort when the mother might die, but they often brought in more germs. Children (like Estelle and René's one-year-old daughter and two-year-old son and her ten-year-old daughter) were usually sent to stay with family as birth approached so they would not have to witness or hear it.

95. If childbed fever (blood poisoning) set in during the labor process, it could kill the mother.

96. Many new mothers died as a result of exhaustion, dehydration, high blood pressure infection, hemorrhage or convulsions.

97. Jeanne De Gas was baptized at the Catholic ceremony on February 5, 1873, in New Orleans, and Edgar Degas was named her godfather.

Chapter 7

98. The land where City Park sits was once part of the Allard Plantation. J. McDonough acquired the plantation from Allard in 1845, and the land was given to New Orleans in 1850.

99. Financial hardship has been a top risk factor for suicide attempts. People who have experienced severe financial strain may have had a twenty-fold higher risk of attempting suicide than those who had not encountered hardship. Being in debt or facing a financial crisis, unemployment, past homelessness and having lower income were each associated with suicide attempts. According to Anton J.L. van Hooff, hanging was the most common suicide method in primitive and pre-industrial societies.

100. The Catechism of the Catholic Church deals with the question of why suicide is wrong: "We are stewards, not owners, of the life God has entrusted to us," and thus, our lives are "not ours to dispose of."

101. Edgar reported his daily visit to his family's office to check for mail in one of his early letters.

102. The nearest big city near New Orleans was Charleston, South Carolina, with a population of a mere 20,000, while New Orleans boasted 168,000. Interview with Dr. Justin Nystrom, August 2022.

103. "De Gas Bros. (René and Achille), cotton buyers, 3 Carondelet" was included in the New Orleans directory in 1873.

104. Cotton and insurance were Uncle Michel's businesses. He trained in cotton in Liverpool in the 1820s and 1830s.

105. Art historian Marilyn Brown suggests that René De Gas could be perusing the fatal announcement of the dissolution of the firm in the *Picayune* of February 1, 1873.

106. The year 1873 was one of epidemics. Death rates from diseases like smallpox, cholera and yellow fever soared in urban areas, like New Orleans, as residents packed into small areas spread disease quickly. The filth that accumulated in the Crescent City and the swampy areas that surrounded it attracted disease-carrying

insects and polluted the water supply. One of the worst happened in 1873, during the time of the Freedman's Bank. The panic started with a problem in Europe when the stock market crashed. Investors began to sell off the investments they had in American projects.

107. The Panic of 1873 was the financial crisis that triggered an economic depression in Europe and North America (1873–79). In Britain, the panic started two decades of stagnation known as the "Long Depression" that weakened the country's economic leadership. In the United States, the panic was known as the "Great Depression" until the events of 1929 and the early 1930s set a new standard. In the United States, from 1873 to 1879, eighteen thousand businesses went bankrupt, including eighty-nine railroads. Ten states and hundreds of banks went bankrupt. Unemployment peaked in 1878, long after the initial financial Panic of 1873 had ended. Different sources peg the peak U.S. unemployment rate anywhere from 8.25 to 14 percent. People lost confidence in the banks and withdrew their money at alarming rates. Banks loaned too much money because so many people were struggling financially.

108. The start of the Great Financial Panic of 1873 was marked by the closing of the doors of the Stock Exchange on its members on Saturday, September 20.

109. In 1867, Musson formed a partnership known as Musson, Prestidge and Co., which moved in 1869 to Carondelet Street.

110. Brown, *Degas and the Business of Art*, cited an article from the historic *Daily Picayune*.

111. Achille was listed in the New Orleans city directory in 1873, residing at 87 Royal Street in the French Quarter. However, he was not listed in the 1874 directory. René was listed in both, with his address at 372 Esplanade Avenue.

"De Gas Bros. (René and Achille), cotton buyers, 3 Carondelet" was included in the New Orleans directory in 1873. That same year, De Gas Brothers was dissolved. A brief article in the *New Orleans Republican* shows the business was liquidated to pay debts. "The co-partnership hereto existing between the undersigned, under the firm, De Gas Brothers, is this day dissolved by mutual consent." August 1, 1873.

112. René made an ill-advised investment in imported cotton in 1866, using funds entrusted to him by his father and his siblings, including Edgar. It was a substantial loss of about $8,000.

113. René wrote, "C'est n'est pas gaie."

114. For additional information on Degas' cotton painting, refer to Marilyn Brown, *Degas and the Business of Art*.

115. Was Edgar showing ambivalence about progress and American capitalist enterprises? Maybe he was portraying Americans as self-involved. He could have been showing uneasiness about innovation and tradition, according to Marilyn Brown, *Degas and the Business of Art*.

116. In 1872, there was political turmoil in New Orleans with growing politicization. It was a difficult time with a lot of change. The presence of freedmen was a big shock to people like Michel Musson. The journey from slavery to freedom to citizenship to political enfranchisement was a big deal. For some people, that was

difficult to accept and adjust to, so there was a lot of reaction to it. Interview with Dr. Justin Nystrom, August 2022.

117. Some say Michel Musson was a diehard believer in the Confederacy. He had invested so heavily in the Confederacy that he didn't emotionally recover from it, leading him to join with enthusiastic members of the White League, like Fred Ogden. Interview with Dr. Justin Nystrom, August 2022.

118. This battle occurred on March 5, 1873, in New Orleans.

119. Democrats (who supported John McEnery) fought against the city's integrated Metropolitan Police, which protected Governor Kellogg's Republican administration. Both McEnery and Kellogg had claimed victory in the 1872 election and established military and legislatures, and McEnery planned a coup. Kellogg maintained power, though unstable, during the remaining years of the Reconstruction.

120. The house was Edgar's primary place to live and paint, and it was in jeopardy of being lost. Within a few years, Uncle Michel would indeed have to move the family out of their house on Esplanade into a smaller rental property.

121. The White League regarded itself as a militia to defend the right government of the state. Its members had weapons to back their ideas, having early on won the support of the First Louisiana Regiment, a military organization made up entirely of former Confederate soldiers.

122. Political events in the city gave the Missing Links carnival a special twist. It was to be assumed that the usual cast of Civil War villains would be lampooned at the baser rungs of the descent of man.

123. The brother of Edgar's maternal grandmother, Marie Rillieux, was named Vincent Rillieux Jr., and he married a free woman of color, Constance Vivant. Vincent's siblings were supportive of their partnership and children.

124. The exact date of Edgar's departure is difficult to ascertain, as the problem with passenger ship records is that only incoming vessels are tracked, according to Jennifer Navarre, senior reference associate at the Historic New Orleans Collection, Williams Research Center. Incoming vessels are tracked by the port of entry, and outgoing vessels are not tracked per se.

Chapter 8

125. Their financial predicament was partially due to Auguste. He had written to Uncle Michel in 1864, stating, "I authorize you to sell Edgar's house [in New Orleans] and to convert the proceeds into Confederate bonds."

126. In 1866, René arranged a loan from his father's bank to start his own business with his brother Achille in New Orleans. René never paid back any of his loans from his considerable losses in speculating cotton in 1866, and this plagued the family during these economic crises of the 1870s. René's large debts to the bank became an urgent problem, and stern efforts to force him to make good on these were unsuccessful. René refused to make good on debts that had launched the problem.

127. Disturbed thinking led René to bond with the White League and organize anti-government terrorism.

128. The ships at the levee brought in tuberculosis, plague, scabies, smallpox and, always, cholera. Paris was full of germs, but the contagions of New Orleans were fiercer.

129. Some scholars state his departure date was March 6, 1873, which would have been the day after the violence of the First Battle of the Cabildo.

130. In a letter to Tissot, Edgar shared that he planned to depart New Orleans during the first few days of March with Achille.

131. In New Orleans, Edgar was right to be reluctant about painting children, knowing a great percentage of them might die. His paranoid Uncle Michel had buried all his pre-adolescent sons. Auguste had buried a son, Georges, born one year after Edgar.

132. In the years 1875 to 1881, several of Edgar Degas' family members in New Orleans died. Estelle's children passed away: Jeanne De Gas (age five), René Henri De Gas (age one), Michel Pierre De Gas (age eleven) and Jo Balfour (age eighteen). Mathilde (age thirty-seven) and her daughter, Jeanne Marie Bell (newborn infant), also died.

133. After Mathilde's death, Will Bell and their children evacuated the Musson house and moved to Canal Street. Later, Uncle Michel, Désirée, Estelle and children moved to North Rampart in the Old Quarter. Following this home, Estelle would live in a house at 125 Esplanade, which her cousin, well-known New Orleans architect James Freret, designed.

134. René gave Estelle a gold enamel, diamond and opal finger ring in the Neolithic style shortly before he eloped with America. Perhaps it was a goodbye gift. The ring is in the collection of Mrs. Arthur Belge.

135. America Durrive Olivier was born in 1855.

136. The Olivier and De Gas families were deeply entwined. America was the godmother to Edgar Gaston in 1875. Leonce was the godfather to Marie Bell in 1875.

137. According to family tradition, René's belongings, including much correspondence, were burned after he abandoned Estelle.

138. Henri Degas died in 1877.

139. It wasn't a surprise that René didn't pay child support to Estelle. According to ledgers kept painstakingly by her father, René sent only $2,000 between 1878 and 1883, having missed more payments than he made. More and more of Michel's finances slipped away, so he downgraded from the large rental home to smaller quarters farther away from the better neighborhoods of the Vieux Carré. Grief-struck, Uncle Michel died in 1885. He was insolvent, leaving a sum of $3,666 (mostly inherited from his brother Eugene), all of which he owed Estelle, who had lent him over $4,000.

140. René would have a total of eleven children, three with America. But none of hers would die, while Estelle would lose all but two of hers.

141. René stayed in New Orleans, perhaps using Estelle as an excuse to hide and siring two more children with her. These children wouldn't survive infancy.

142. Like René, Achille had moved to New Orleans to make his fortune. After the dissolution of De Gas Brothers, Achille worked for John Leisy and Company, which seems to have had business dealings in New York.

143. In one letter, Achille expressed worry for the Musson family due to the diseases and death in New Orleans. He asked why they wouldn't leave New Orleans. *Degas-Musson Family Papers*, Tulane University Libraries, Special Collections.

144. Achille fathered a child by a dancer. Later, he would pull out a revolver at the Stock Exchange and shoot his mistress's husband wildly when he approached and tried to beat him with a cane.

145. Achille De Gas married the niece of his aunt Odile Longer Musson, Emma Hermann (b. 1838).

146. Edgar once said, "If the leaves on the trees didn't move, how sad the trees would be, and so would we!"

147. Edgar kept reaching out from New Orleans to his artist friends to see what was going on in Paris. These artists would be a part of the Impressionist group that he would form.

148. In 1876, Degas organized the Impressionists' Second Exhibition. Maybe because of this support, he became an aggressive artist fighting for the support of independent Impressionist artists and exhibiting in most of their shows.

149. Degas exhibited at the Boulevard des Capuchines and worked for that Salon des Realistes.

150. Degas began mastering pastels, as well as oil on canvas. The dry medium, which he applied in complex layers and textures, enabled him more easily to reconcile his facility for line with a growing interest in expressive color.

151. Edgar became part of a family of artists he admired who were searching for "God" through the play of light on canvas. They exhibited in a show they called "The Salon of the Rejected Ones." One audacious reviewer insulted them and called them "the Impressionists," and the term stuck. Recognized as an important artist in his lifetime, Degas is now considered one of the founders of Impressionism.

152. Degas sold a few of his New Orleans artworks: *A Cotton Office in New Orleans*, which willingly sold to the museum in Pau in 1878, as well as *Woman with a Vase of Flowers* and *The Pedicure*, which made their way into a private collection and then to the Louvre. He may have studied these artworks before his eyes failed. He attached strips of canvas to the top and bottom of the *Portrait of Estelle Musson*, sketching it in an extended composition that he never completed.

153. Edgar kept portraits of his Parisian family in his studio, as well. He had a particular attachment to one of his father with the musician Pagans. These portraits were discovered nestled inside the contents of Edgar's studio after his death in 1917.

154. Estelle's daughter Odile said that she was gentle and kind until the end (she died in 1909). Frail but stoic, Estelle remained in New Orleans and outlived her sisters Mathilde (by thirty-one years) and Didi (by seven years). Their father, Michel Musson, died in 1885, and in his obituary, he was praised for his "public usefulness and unblemished honor." His family's difficulties were referenced in

his death: "For a long period, Michel was weighted by family cares and afflictions, this contributed in the end to his departure from this earth."

155. These were Estelle and René's only two children who survived to adulthood.

156. Odile and Gaston braved the Atlantic and fought for half of René's estate. The other half went to René's three children by America. So, one-quarter of Edgar's estate came back to New Orleans through Estelle.

Backmatter

157. Dr. Feigenbaum also has held leadership positions in the College Art Association and Association of Research Institutes in Art History.

158. Constance Vivant and Vincent Rillieux Jr. raised six children. Their son Norbert became a famous inventor and chemical engineer.

159. Vincent Rillieux (Edgar Degas's great-uncle) and Constance Vivant (Norbert Soulié's aunt).

160. In the nineteenth century, the community of free people of color was an interconnected network in New Orleans. Entrepreneurship through real estate was a community-oriented endeavor. Several structures in New Orleans built by free people of color still exist, such as the Louisiana Sugar Refinery. Dr. Tara Dudley, architectural historian, wrote her dissertation on the free people of color community in New Orleans: "Ownership, Management, and Entrepreneurship: Gens de Couleur Libre and Architecture of Antebellum New Orleans." Interview with Dr. Tara Dudley, October 2022.

161. Theirs was likely a common-law marriage. They lived together as husband and wife. In New Orleans, a law forbidding mixed-race marriages remained.

162. Constance Vivant and Vincent Rillieux had several children, including Norbert Rillieux, the well-known steam engineer and inventor.

163. To access historical documentation, Dr. Dudley researched the archives at the New Orleans Historic Collection and the collections of the New Orleans Public Library and Louisiana Digital Library. She reviewed documentations that evidenced free women of color in left-handed marriages acquired their property. She also studied free people of color families in antebellum New Orleans. Interview with Dr. Tara Dudley, October 2022.

164. Additional research of the life of Norbert Rillieux is currently underway by Jean-Jacques Patard, an engineer and graduate of École Centrale in Paris. Interview with J.J. Patard, October 2022.

165. Constance Vivant was a free woman of color. Constance's half sister Eulalie Soulié was also a free woman of color. She had a son named Norbert Soulié.

166. In the late 1800s, Norbert Soulié moved to France with his uncle.

167. Interview with Dr. Tara Dudley, October 2022.

168. Norbert Soulié has provided information on his family history to Tara Dudley.

169. Terry shared vivid memories of her grandmother Dora's 1920s bungalow-style home with gorgeous antique furniture. Later, Terry saw some of these pieces again in the *Degas in New Orleans* exhibition at the New Orleans Museum of Art. She recalled a dinner table set for many people with lovely linen, sterling silver and china. Each place setting had beautiful small crystal and silver salt and pepper shakers and a crystal bowl of sugar with a silver spoon. Family members told Terry that her father was born with a silver spoon in his mouth. She has this baby silver spoon!

170. It was also the last time Degas would see his aunt Odile before her death.

171. The Art Institute of Chicago (AIC) includes this early New Orleans family portrait in its collection. This painting was celebrated in the museum's 1984 *Degas, Beyond Impressionism* exhibition catalogue, R. Brettell and S. McCullagh. In speaking with Dr. Gloria Groom (chair of painting and sculpture of Europe) and David and Mary Winton Green (curator at the Art Institute of Chicago), we learned she also noticed the Musson portrait's resemblance to the Bellelli family portrait.

172. For more information, refer to Jeanne Sutherland Boggs' 1988 book, *Degas*.

173. Ibid., 181–83.

174. Dr. Jay Clarke is an esteemed art historian who has curated a variety of exhibitions, including *The Impressionist Line from Degas to Toulouse-Lautrec* and *Picasso | Encounters*. She specializes in the materials, processes and markets of prints and drawings circa 1900. Her publications include *Becoming Edvard Munch: Influence, Anxiety, and Myth*; *Käthe Kollwitz: The Art of Compassion*; and *Picasso | Encounters: Printmaking and Collaboration*.

175. Edgar's letters from New Orleans, 1872–73.

176. Interview with Degas curator Dr. Isolde Pludermacher, October 2022.

177. Additional information about Degas' *Cotton Office* painting can be found in Marilyn Brown's book *Degas and the Business of Art*.

178. Kate Smith referenced information about this artwork that was written by Teri Hensick, the now retired former head of paintings conservation at Harvard Art Museums, "Process or Product?"

179. Dr. Corbeau-Parsons previously worked for ten years as the curator of paintings, drawings and sculptures at the Tate Museum. Tate includes four museums (Tate Liverpool, Tate Britain, Tate St. Ives and Tate Modern) with a large collection, but their collection of drawings is smaller than that of D'Orsay Museum.

180. Dr. Corbeau-Parsons curated a pastel exhibition in 2023 that included pastels by Degas, as well as by others. Thematic arrangement centers on landscapes, nudes, intimate homelife scenes, rural scenes and symbolism.

181. Both *Woman Getting out of the Bath* and *Ballet* were exhibited in the third Impressionist exhibition in 1877, the first time the Impressionists embraced the name given to them as an insult.

182. *Degas-Musson Family Papers*, January–November 1861, Tulane University Libraries, Special Collections.

183. Letter to Michel Musson from Edgar Degas in Paris, in which Edgar gives news of the arrival of the Musson women in France, June 24, 1863, *Degas-Musson Family Papers*, Tulane University Libraries, Special Collections.

184. Letter from Didi Musson in Bourg, November 18, 1863, *Degas-Musson Family Papers*, Tulane University Libraries, Special Collections.

185. Letter to Michel Musson from Marguerite Degas in Paris, wishing him happy new year, December 31, 1863, *Degas-Musson Family Papers*, Tulane University Libraries, Special Collections.

186. Correspondence, July 1864, *Degas-Musson Family Papers*, Tulane University Libraries, Special Collections.

187. Letter to Michel Musson from René Degas in Bourg, giving family news, February 11, 1864, *Degas-Musson Family Papers*, Tulane University Libraries, Special Collections.

188. *Degas-Musson Family Papers*, Tulane University Libraries, Special Collections.

189. Letter to Michel Musson from René Degas in Paris, saying that he was shown Michel's letter. *Degas-Musson Family Papers*, Tulane University Libraries, Special Collections.

190. Letter to Michel Musson from René Degas at the Hotel Tavistock in London, in which he recounts a disastrous speculation in cotton futures, July 25, 1866, *Degas-Musson Family Papers*, Tulane University Libraries, Special Collections.

191. Correspondence from René Degas, June 1872, *Degas-Musson Family Papers*, Tulane University Libraries, Special Collections.

192. Ibid.

193. Correspondence, March–May 1873, *Degas-Musson Family Papers*, Tulane University Libraries, Special Collections.

REFERENCES

Adhémar, Hélène. "Edgar Degas et 'La scene de guerre au moyen age.'" *Gazette des Beaux-Arts* 70 (November 1967): 295–98.

Al-Gailania, Salim, and Angela Davisb. "Introduction to 'Transforming Pregnancy since 1900.'" *Studies in History and Philosophy of Biological and Biomedical Sciences* (September 2014): 229–32.

American Battlefield Trust. "Civil War Casualties. The Cost of War: Killed, Wounded, Captured, and Missing." www.battlefields.org/learn/articles/civil-war-casualties.

Bailey, Joanne. "English Marital Violence in Litigation, Literature and the Press." *Journal of Women's History* (Winter 2007).

Baptismal Record of Jeanne Degas, February 5, 1873. St. Rose of Lima Church, Appendix 281. Edgar is listed as the godfather.

Benfey, Christopher. "De Gas and New Orleans: Exorcising the Exotic." In *Degas in New Orleans: A French Impressionist in America*, edited by Gail Feigenbaum. Seattle: Marquand Books, Inc., 1999.

———. *Degas in New Orleans: Encounters in the Creole World of Kate Chopin and George Washington Cable*. Berkeley: University of California Press, 1997.

Boggs, Jeanne Sutherland. "'Mme. Musson and Her Two Daughters' by Edgar Degas." *Art Quarterly* 19 (Spring 1956): 60–64.

Brown, Marilyn. *Degas and the Business of Art: A Cotton Office in New Orleans*. University Park: Pennsylvania State University Press, 1994.

Byrnes, Jim. *Edgar Degas: His Family and Friends in New Orleans*. New Orleans: Isaac Delgado Museum of Art, 1965.

Byrnes, James B., and Victoria Cooke. Appendix I, "De Gas Family in New Orleans: A Who's Who." In *Degas in New Orleans: A French Impressionist in America*, edited by Gail Feigenbaum. Seattle: Marquand Books, Inc., 1999.

Capers, Gerard M. *Occupied City: New Orleans under the Federals: 1862–1865.* Lexington: University of Kentucky Press, 1965.

Cody, Lisa Forman. "The Politics of Illegitimacy in an Age of Reform: Women, Reproduction, and Political Economy in England's New Poor Law of 1834." *Journal of Women's History* (Winter 2000).

Curious Historian. "The Reality of Childbirth in the 1800s." December 13, 2018. curioushistorian.com/the-reality-of-childbirth-in-the-1800s.

Daily Picayune, December 10, 1872.

Degas and Music was organized by Richard Kendall, the curator-at-large at the Sterling and Francine Clark Art Institute in Williamstown, Massachusetts, and the independent scholar and dance historian Jill De Vonyar. *Antiques, Art, Furniture and Decorative Arts*, July 29, 2009.

Derrida, Jacques. *Memoirs of the Blind: The Self-Portrait and Other Ruins.* Translated by Pascale-Anne Brault and Michael Naas. Chicago: University of Chicago Press, 1993, 2.

Dobney, Jayson Kerr. Department of Musical Instruments, Metropolitan Museum of Art, October 2004.

Dudley, Tara, architecture historian. Interview with Dr. Rory O'Neill Schmitt, October 2022.

———. "Ownership, Management, and Entrepreneurship: Gens de Couleur Libre and Architecture of Antebellum New Orleans." PhD diss., University of Texas at Austin, 2011.

Faulkner, Carol. "Review: *Prostitutes and Female Patriots in the Civil War Era.*" *American History* 38, no. 1 (March 2010): 87–92.

Faust, Drew Gilpin. "Death and Dying." National Park Service. www.nps.gov/nr/travel/national_cemeteries/death.html.

———. "Numbers on Top of Numbers: Counting the Civil War Dead." *Journal of Military History* (2006).

Feigenbaum, Gail. *Degas in New Orleans: A French Impressionist in America.* Seattle: Marquand Books, Inc., 1999.

Fèvre, Jeanne. *Mon Oncle Degas.* Geneva: Editions Pierre Cailler, 1949.

"Financial Panic of 1873." U.S. Department of the Treasury. home.treasury.gov/about/history/freedmans-bank-building/financial-panic-of-1873.

Gorman, Kathleen L. "Civil War Pensions." *Essential Civil War Curriculum*, January 2018. For definitive analysis, see *History of the Union Federal and Confederate State Pensions Systems Protecting Soldiers and Mothers.* Cambridge, MA: Harvard University Press, 1992.

Grey, Tobias. "Impressions of Degas: The Painter's Life and Character Revealed in a New Bilingual Edition of His Correspondence." *Wall Street Journal*, April 17, 2020.

Harris, Wesley. "1873: A Year of Epidemics." *Piney Woods Journal.* www.thepineywoods.com/1873EpidemicJun16.htm.

Havemeyer, Louisine. *Sixteen in Sixty.* New York, 1964, 247.

Keith, Leeanna. "1873 Comus Parade." 64 Parishes. 64parishes.org/entry/1873-comus-parade.

Kellogg, John. *Ladies' Guide in Health and Disease*. London: Forgotten Books, 2018.

Kendall, Richard. "De Gas and the Contingency of Vision." *Burlington Magazine* 130, no. 1020 (March 1988): 180–97.

King, Edward. *The Great South*. New York: Harpers, 1875, 28–29.

"Local Weather History: The Great Blizzard of 1873." WLFI. www.wlfi.com.

"Louisiana State Museum Online Exhibits the Cabildo: Two Centuries of Louisiana History." Louisiana: Feed Your Soul. www.crt.state.la.us/louisiana-state-museum/online-exhibits/the-cabildo/index.

Loyrette, Henri. *Degas*. Paris, 1991.

Mannering, Douglas. *The Life and Works of Degas*. UK: Parragon Book Service Limited, 1994, 6–7.

Miller, Dora, the great-granddaughter of Gaston De Gas Musson. Box II, folder 52a.

New York Times. "Steam Ship *Scotia* Passenger List." October 23, 1872. New York Historical Society.

Nystrom, Dr. Justin. Interview with Dr. Rory O'Neill Schmitt and Dr. Rosary O'Neill, August 2022.

O'Connor, Eileen. "Medicine and Women's Clothing and Leisure Activities in Victorian Canada." *Yale Journal for Humanities in Medicine* (n.d.).

Pantazzi, Michael. "Lettres de Degas a Therese Morbilli conservées au Musée des Beaux-Arts du Canada." *Racar* 15, no. 2 (1988).

Patard, Jean-Jacques, author and researcher of Norbert Rillieux. Interview with Dr. Rory O'Neill Schmitt and Dr. Rosary O'Neill, October 2022.

Reff, Theodore. *The Notebooks of Edgar Degas: A Catalogue Raisonné of the Thirty-Eight Notebooks in the Bibiliotheque National and Other Collections*. Oxford, 1976, 162–71.

Rewald, John. "Degas and His Family in New Orleans." In *Gazette des Beaux-Arts*, August 1946, 123. An original copy with a note signed and dated: "For Mr. Gaston Musson with the expression of my very deep gratitude for his precious and untiring help. John Rewald, N.Y., Jan. 1947." Collection of Edmund B. Martin Jr.

Roberts, Adam. "Infant Mortality: Then and Now." *Morphosis*, September 28, 2013.

Roser, Max. "Mortality in the Past: Around Half Died as Children." Our World in Data, June 11, 2019. data.unicef.org/wp-content/uploads/2018/10/Child-Mortality-Report-2018.pdfAnthony.

Succession papers of Michel Musson, Civil District Court for the Parish of Orleans, archives, and docket 24568. Filed July 21, 1888, New Orleans Public Library.

Thomas, Abreeza. "Edgar Degas and New Orleans' Paintings." *Daily Art Magazine*, May 16, 2022.

Thomson, Richard. *Degas: The Nudes*. London: Thames and Hudson Ltd., 1988, 75.

Thorpe, J. "What's the History of Miscarriage? 7 Reasons Why People Once Thought Women Lost Pregnancies, from Demons to Flatulent Wombs." *Bustle*, May 21, 2015.

Vella, Christina. "The Country for Men with Nerve." In *Degas in New Orleans: A French Impressionist in America*, edited by Gail Feigenbaum. Seattle: Marquand Books, Inc., 1999.

Vok, A., and J. Atkinson. "Infant and Child Death in the Human Environment of Evolutionary Adaptation." *Evolution and Human Behavior* 34, no. 3 (May 2013): 182–92.

The Letters of Edgar Degas and His Family

Degas-Musson Family Papers. Special Collections, Howard-Tilton Memorial Library, Tulane University. archives.tulane.edu/repositories/3/resources/1844/collection_ organization.

Edgar's letters from New Orleans in *Degas in New Orleans: A French Impressionist in America*, edited by Gail Feigenbaum. Seattle: Marquand Books, Inc., 1999. Including, among others: letter to Lorenz Frølich, Danish painter, November 1872; letter to James Tissot, November 1872; letter to Désiré Dihau, November 1872; letter to Henri Rouart, December 1872; letter to James Tissot, February 1873.

Unpublished letter of Edgar Degas, Archives of the History of Art, Getty Center for the History of Art and Humanities and 735, n. 34. Los Angeles, no 860070, partly translated in Paris, Ottawa, New York, 488.

ABOUT THE AUTHORS

Rory O'Neill Schmitt, PhD, has penned two books with Arcadia Publishing and The History Press: *Navajo and Hopi Art in Arizona* (2016) and *New Orleans Voodoo: A Cultural History* (2019). A researcher with over fifteen years of experience, Dr. Schmitt centers her inquiry on pedagogy, identity, art and community. She studied the cathartic process of artmaking at the School of Visual Arts in New York City and worked as a board-certified art therapist and adjunctive therapy director in Southern California. A filmmaker and photographer, she believes in the power of narratives and visual art to connect humanity. Dr. Schmitt currently manages faculty development at University of Southern California, Bovard College.

Rosary O'Neill, PhD, is a Senior Fulbright Drama Specialist and winner of nine Fulbright awards, including five to Paris to study Degas. She has published nineteen plays with Concord Publishers (aka Samuel French in New York City), including *Degas in New Orleans* and *Marilyn/God*; three play anthologies; and six books. A professor emerita at Loyola University, New Orleans, Rosary founded the first repertory theater in New Orleans, Southern Rep, and is a member of the Playwrights Division of the Actors Studio, New York City. She has participated in residencies at Harvard University, Tyrone Guthrie Theatre Center, American Academy in Rome and Irish Cultural Center in Paris.